IMAGES
of America

THOMAS DREW'S
SOUTH SHORE

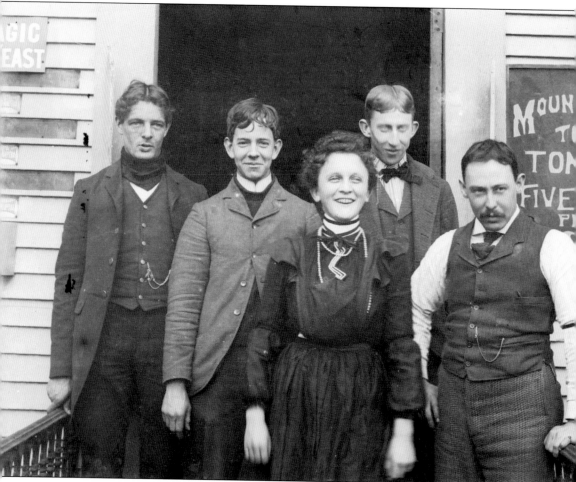

Thomas Drew captured hundreds of South Shore images, including buildings, events, and landscapes. However, he seemed to obtain particular pleasure from photographing people, whether it was family or a group like this at the front door of his store. In this photograph are Ernest F. Bates (second from left), Pauline Phillips (third from left), and Eugene Phinney (on the right). Bates was Thomas Drew's nephew, and he succeeded Drew in operating the Drew store in 1910. (Courtesy of the Thomas Drew Photography Collection, Hanover Historical Society.)

ON THE COVER: This image shows the front of the Thomas Drew Store on Broadway in South Hanover, Massachusetts, around 1910. This image was scanned directly from a glass plate negative taken by Thomas Drew. (Courtesy of the Thomas Drew Photography Collection, Hanover Historical Society.)

IMAGES
of America

THOMAS DREW'S
SOUTH SHORE

Leslie J. Molyneaux

ARCADIA
PUBLISHING

Published by Arcadia Publishing
Charleston, South Carolina

Printed in the United States of America

Library of Congress Control Number: 2017957979

For all general information, please contact Arcadia Publishing:
Telephone 843-853-2070
Fax 843-853-0044
E-mail sales@arcadiapublishing.com
For customer service and orders:
Toll-Free 1-888-313-2665

Visit us on the Internet at www.arcadiapublishing.com

*"The negative is like the composer's score . . .
the print is the performance."*

—*Ansel Adams*

CONTENTS

ACKNOWLEDGMENTS

Unless otherwise noted, all images in this book are taken from the Thomas Drew Photography Collection of the Hanover Historical Society. Virtually all of the images in the collection were taken by Drew, and most of the images used in this book have been scanned from his glass plate negatives by the author. Some scenes have been cropped by the author to remove flaws (damaged negatives) or to make images more usable for publication. There are some real-photo postcards in the collection unaccompanied by their negatives, and thus these images could possibly have been taken by other photographers. Numerous Drew photographs have been used in prior publications, some of which include *History of the Town of Hanover* (1910) by Jedediah Dwelley and John F. Simmons, Stetson Kindred publications, Hanson Town histories, Norwell town histories, Hanover town histories, and others, often without Drew attribution. Any such images used in this book are taken from images in the Thomas Drew Photography Collection.

I would like to thank Susan Basile and the Halifax Historical Society Museum for help in researching Halifax history. I feel like I have walked in George Drew's footsteps on River Street. Thanks also to the Holmes Library in Halifax for research assistance. In Hanson, the history room of the Hanson Library was most useful, and Hanson Historical Society vice president Allen Clemons identified images that would have otherwise remained unknown. Scituate Historical Society President Dave Ball provided valuable information. Hanover Historical Society co-president Judy Grecco and board member Joe Grecco gave me a tour of the Stetson Shrine in Norwell and the dam sites along the Indian Head River in Hanover, permitting me to describe photographs of these areas properly, and also identified unknown images for me. Hanover Historical Society board member John Galluzzo identified images as well. Kenton Greene identified an early Hanover photograph. In Marshfield, Marshfield Historical Society curator Dottie Melcher and board member Cindy Castro identified scenes from their town. The Dyer Memorial Library in Abington assisted in identifying some of the photographs.

Of course, none of this would have been possible without Alan Phillips's donation of the Thomas Drew Collection of Photography to the Hanover Historical Society. The author's personal collection of Thomas Drew negatives—obtained many years ago from a Phillips family member—was also vital to providing an adequate number of images to publish. He has donated his collection to the society to unify the collection.

Author royalty proceeds from this publication will go to the Hanover Historical Society, a 501(c)(3) nonprofit organization.

INTRODUCTION

Thomas Drew's South Shore is, in one sense, an autobiography, as Thomas Drew's photographic avocation led him to walk in the footsteps of his ancestors in Plymouth County, Massachusetts, photographing family, houses, and landmarks in their home communities. Most of the images in this volume were reproduced from glass negatives developed by Drew in his kitchen darkroom. A few images predate his camera work but were from his family collection. A final few images are photographs taken by the author of Drew's camera equipment or are courtesy images.

Thomas Drew's ancestors had deep roots in Plymouth Colony, as his great-great-great-great-grandmother was Rebecca Alden, daughter of John Alden and Priscilla Mullins, who came on the *Mayflower* in 1620. The family was originally from Plymouth, but early on, some family members became residents of Halifax, Massachusetts.

Thomas took photographs of his uncle and aunt's homes in Plympton, but beginning with his great-great-great-great-grandfather, the Drews were Halifax residents, and Thomas took many photographs there. He obviously spent much time with his grandfather George (1788–1866) and grandmother Sarah. Sarah lived to be 101, passing away in 1886.

The George Drew farm was on River Street in South Halifax. It was rural then and is rural today, looking much as it would have when young Thomas Drew roamed the woods and fields. Hundreds of acres of land on both sides of the Winnetuxett River have been preserved as open space, and tons of hay are harvested in the fields on the south side of the street. When young Tom Drew visited his grandparents' farm, there was much to interest a boy. The Zadock Thompson (1747–1787) house was nearby, as were the mill and box factory started by Thompson many years earlier. One photograph of the mill bears the notation "I spent many days here."

Cyrus Drew (1820–1895) was born in Plympton; he married Evelina Donaldson in Falmouth, Massachusetts, on December 29, 1844. Thomas was born in Falmouth on November 3, 1845. The Drew family moved to Hanson, Massachusetts, before 1849 and purchased the home at 55 Spring Street in Hanson in December 1857. It was here that their other three children were born and where Cyrus spent the rest of his life. He operated a general store first at Harding's Corner on what was then Willow Street (now Washington Street) and later, in the 1870s, at his home.

Thomas, the subject of this book, worked in his father's store before eventually opening his own.

Thomas and his father both served in the Civil War. After the war, Thomas married Ella J. Bourne on July 2, 1868, and they had two children, Jane (born February 11, 1871) and Thomas W. (born February 3, 1874). Thomas purchased his father's store in October 1874 and sold it in 1892. The 1879 *Atlas of Plymouth County* listed him as the proprietor of the Willow Street store formerly run by his father, but he soon moved out of town to operate a store in a South Hanover building owned by E.Y. Perry. Thomas purchased a house fronting the Indian Head River at 1164 Broadway on September 1, 1888; this was his home until his death in 1913. The US Post Office was located in the E.Y. Perry block, and Drew was appointed postmaster of the South Hanover post office on October 6, 1897, by Pres. William McKinley.

It is likely that Thomas was actively taking photographs by the time he moved to Hanover, and it is known that he used the kitchen of his home to develop the glass plate negatives. Two of his cameras are in the collection of the Hanover Historical Society; both cameras were of the Henry Clay design—bellows cameras that were self-cased.

Thomas Drew's large-format camera was made by E. & H.T. Anthony & Company of New York and Chicago and the Whitehead & Hoas Company of Newark, New Jersey. The shutter and lens plate by Bausch & Lomb bears a patent date of October 30, 1900. This camera took 8-by-10-inch negatives. The smaller format camera, which took five-by-seven-inch negatives, bears an American Optical Company label, and the lens marking is Scovill & Adams Company H.C. 203.

Many of Drew's images feature homes and locations connected to his family in some way. He took a number of portraits as well, mostly of family and neighbors.

Drew's cameras and photographs were passed down in his family and carefully preserved. Thirty years ago, the author obtained a large collection of Drew images from the widow of Thomas Drew's grandson and has since donated them to the Hanover Historical Society. Thomas Drew's great-great-great-grandson has donated Drew's cameras and a large collection of images to the society. The Hanover Historical Society is pleased to share these images with the public.

One

MEET THE DREWS

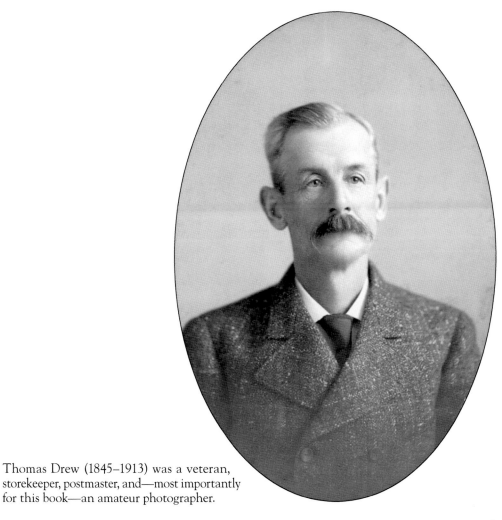

Thomas Drew (1845–1913) was a veteran, storekeeper, postmaster, and—most importantly for this book—an amateur photographer.

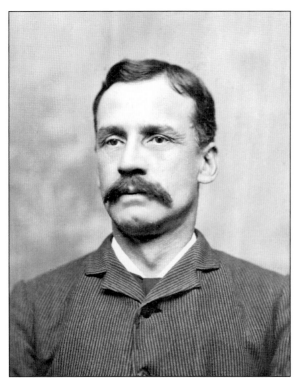

Thomas Drew was born on November 3, 1845, in Falmouth, Massachusetts. He spent most of his life in Hanson and Hanover, Massachusetts, until his death on April 22, 1913.

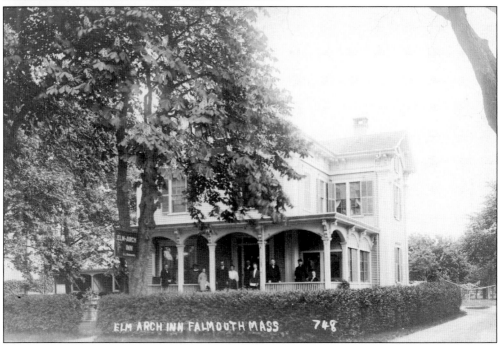

Thomas Drew was born in Falmouth on this site, according to notes on the reverse of this postcard sent to his granddaughter Evalina in 1910. The Elm Arch Inn was built on Main Street as a home by sea captain Silas Jones around 1810 and did not become a year-round inn until about a century later, shortly before this card was mailed.

1686. 1886.

To *Mr. & Mrs. Thomas Drew*

THE
TOWN OF FALMOUTH

cordially invites you to be present at the

TWO HUNDREDTH ANNIVERSARY

OF ITS INCORPORATION.

TUESDAY, JUNE 15th., 1886.

F. A. NYE, Chairman,
J. C. ROBINSON, Sec.

Of the Committee on Invitations.

An early reply will greatly oblige.

Thomas Drew maintained an interest in his birth town long after he had moved to Hanson with his family. The Drew Collection at the Hanover Historical Society contains many postcards of Falmouth locations. Drew was 41 when he attended this 200th anniversary celebration of the town's founding.

Thomas Drew married Ella J. Bourne on July 2, 1868, and the Drew family moved to this South Hanover home on Broadway in 1887. He resided there until his death in 1913. Located on the shore of the Indian Head River, the home was only a few hundred feet from his store.

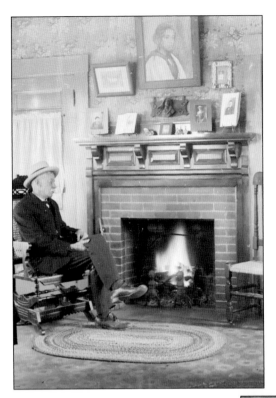

Thomas Drew takes a "selfie" as he sits in his platform rocking chair by a roaring fire. Among the photographs hanging above the mantle is another self-portrait of Drew in Civil War uniform while astride his horse.

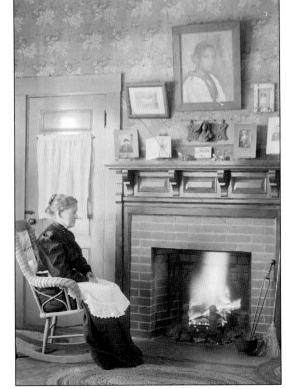

At her home on Broadway in South Hanover, Ella Drew sits in a wicker rocking chair by the fireplace. Three braided rugs, probably made by Ella, cover the linoleum floor.

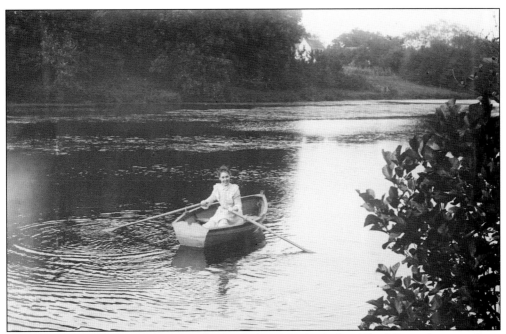

Thomas Drew's daughter, Jane, rows the family boat on the Indian Head River. Jane was born on February 11, 1871. She later married Fred W. Phillips, and their descendants have preserved the Drew materials that made this book possible. Jane had a younger brother, Thomas, who was born in 1874 and died at age 19.

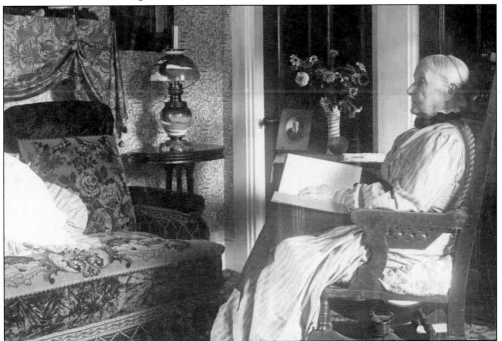

Thomas Drew's mother, Evelina, was born in 1825, so she was in her 70s when this photograph was taken in her parlor with family Bible in hand. That is likely her mother's photograph on the table, along with the carefully arranged flowers and apple.

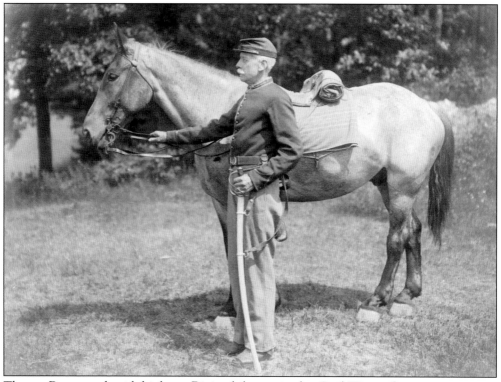

Thomas Drew stands with his horse Dixie while wearing his Civil War uniform.

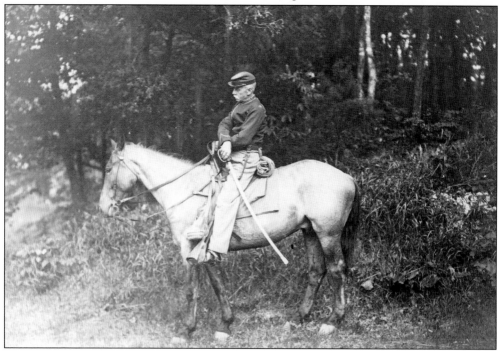

Thomas Drew wears his Civil War uniform and draws his sword as if readying for battle. Actually, he was in uniform for only a few months and never saw action on the battlefield.

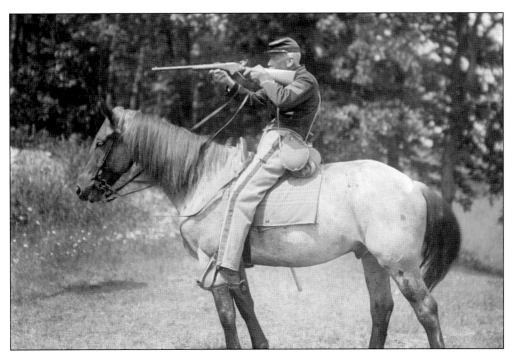

When Thomas Drew took this photograph, almost 50 years had elapsed from the time he served in the Union army. He was probably still a good shot, as folks in this area regularly hunted waterfowl and deer for food.

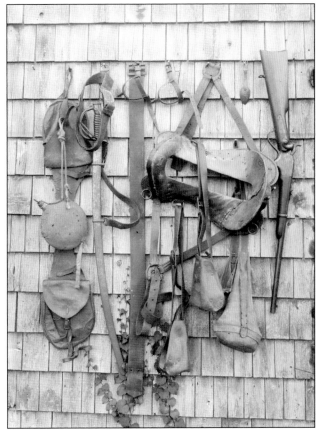

This is a different kind of still-life artwork. Thomas Drew has assembled all of his Civil War equipment on the side of the shed with a few tendrils of vine for accent.

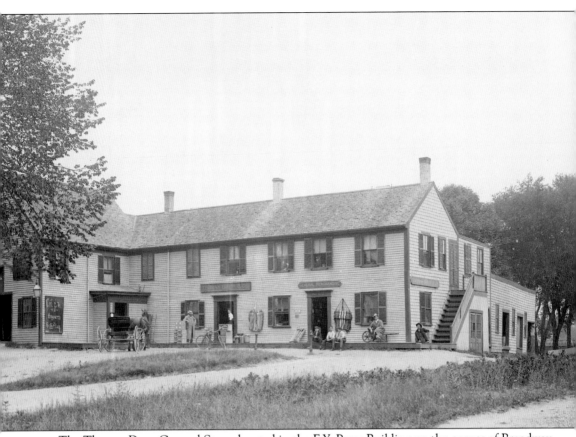

The Thomas Drew General Store, located in the E.Y. Perry Building on the corner of Broadway and Cross Street in South Hanover, was the business center of the village in 1900. Not only was the post office located here, but the store carried most everything. The porch display includes biscuits, a croquet set, hammocks, a wheelbarrow, and clothes baskets. Normally, Drew would not approve of people sitting in baskets he hoped to sell, but it did add a focal point to this photograph. Neighborhood kids were steady customers for the penny candy and other treats available at the store.

Thomas Drew's rolltop desk contains the account books that would be expected for a storekeeper, as well as some of his photographs of local landmarks and family members. The large framed picture appears to be an engraving of Andersonville, the Civil War prison in Georgia where many Union soldiers perished.

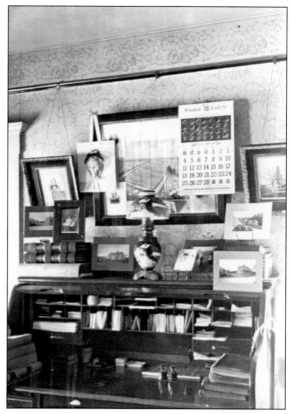

Lamb's tongue, sausage, ham loaf, boned chicken, brisket beef, baked beans, and sugar corn are just some examples of the ample supply of canned goods in the Thomas Drew General Store. The young woman may be Tom's daughter, Jane. The 17th annual Hanover High School reunion poster dates this photograph to December 1902.

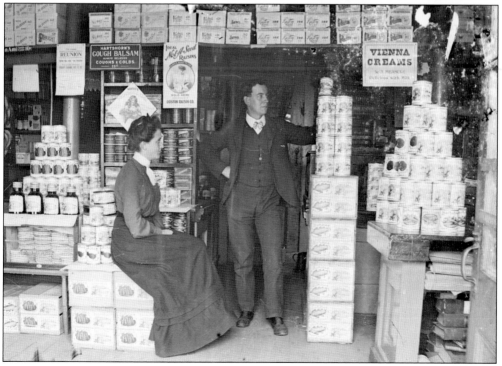

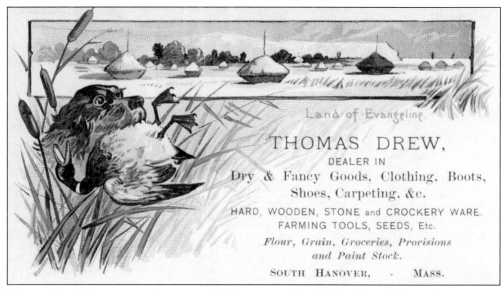

Land of Evangeline.

THOMAS DREW,
DEALER IN
Dry & Fancy Goods, Clothing, Boots,
Shoes, Carpeting, &c.
HARD, WOODEN, STONE and CROCKERY WARE.
FARMING TOOLS, SEEDS, Etc.
Flour, Grain, Groceries, Provisions
and Paint Stock.
SOUTH HANOVER, - MASS.

Thomas Drew's business card was typical of that era, with a full list of available products ranging from groceries and clothing to farm tools and hardware. The title of the scene on the card is "Land of Evangeline," but the hay staddles would have been a common sight on the North River when the salt marsh hay was harvested.

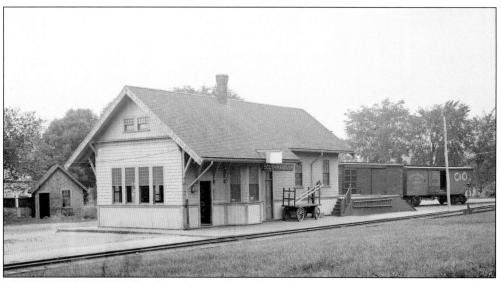

The Hanover Branch Railroad track came through South Hanover and had a station next-door to the Drew store. There was a track siding that made it easy for the store to receive stock without keeping the train from continuing on its way to the end of the line at Four Corners.

Three salesmen await the opportunity to give their sales pitch to storekeeper Thomas Drew. The man at far left is clearly offering natural sponges (there were no synthetic ones then), while the other two are hawking less obvious products.

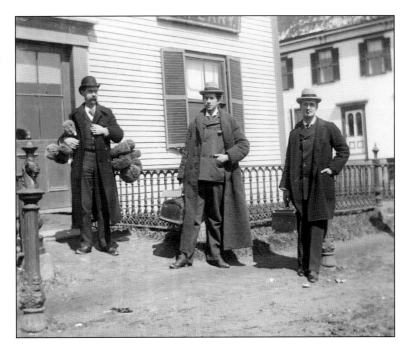

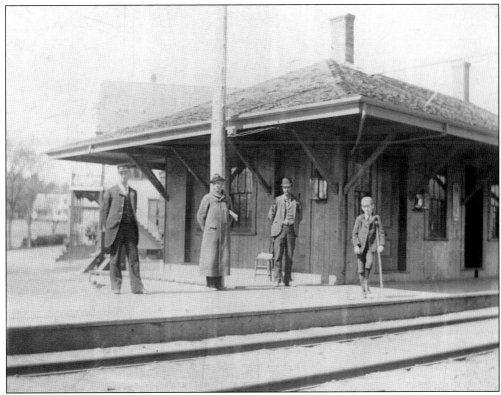

A few folks are waiting for the train. Many locals who worked in Boston took the train to work, as it was much faster than horse and buggy. Others might take the train to Hanover Four Corners. The boy might have been a student at Hanover Academy at Hanover Four Corners.

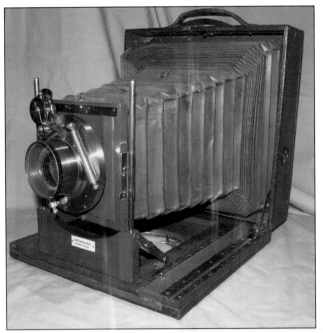

Thomas Drew's large-format camera has a makers' plate that reads, "E. & H.T. Anthony & Co. of New York & Chicago and The Whitehead & Hoas Co., Newark N.J." The lens is a "Bausch & Lomb Opt. Co. Pat. Jan. 6, 1891 Rochester, N.Y./Chicago," while the shutter and lens plate is an 8-by-10-inch Plastigmat (patented October 30, 1900) also by Bausch & Lomb. This little beauty weighs in at a hefty 11 pounds and 11 ounces and is approximately 3 inches deep, 12 inches wide, and 12 inches tall when folded up. It slides into a protective case. (Photographs by the author.)

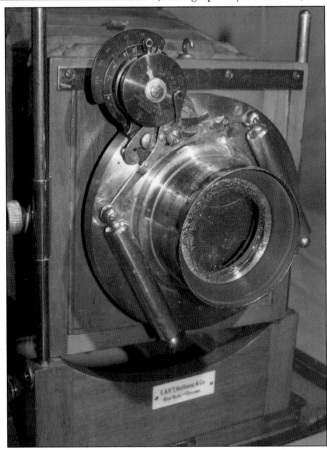

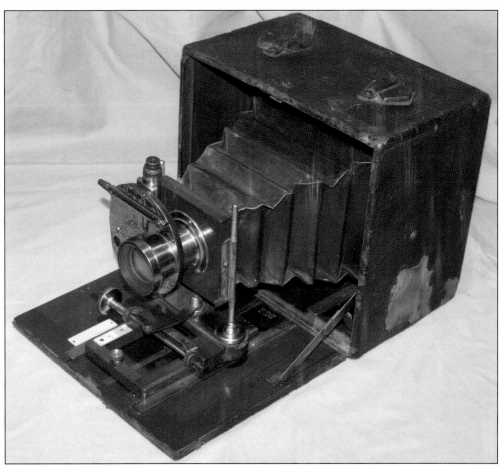

The smaller of Thomas Drew's two cameras weighs six pounds and took five-by-seven-inch glass plate film. The camera is about six inches deep, nine inches wide, and eight inches tall. The case bears an American Optical Company label, and the lens marking is Scovill & Adams Co. H.C. 203. (Photographs by the author.)

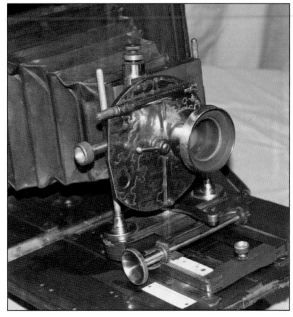

Thomas Drew used his camera skills to create a variety of items. "Christmas greetings From pine hill" is the message on this postcard featuring the Drew rowboat on the shore of the Indian Head River in his backyard. It was sent from Ella Drew to her mother-in-law in Hanson on December 24, 1910. Post offices during this era often used cork cancels with designs cut into bottle corks, which were dipped in ink and then used to cancel the stamp.

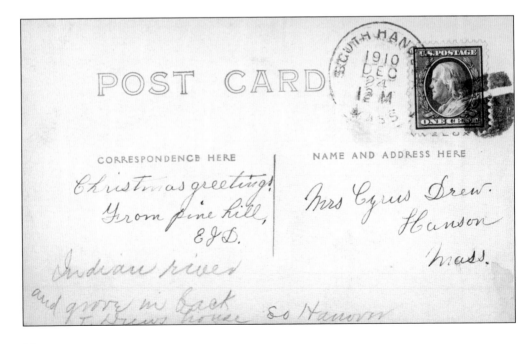

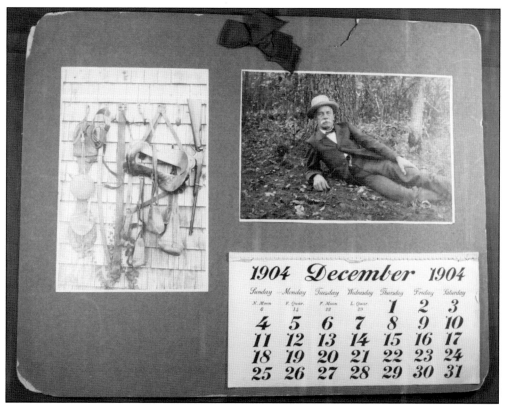

Thomas Drew had an excellent marketing plan of publishing a calendar for customers to hang in their home as a daily reminder that the Thomas Drew store was nearby. This 1904 calendar features Drew reclining under a tree and all of his Civil War gear, including his sword and rifle.

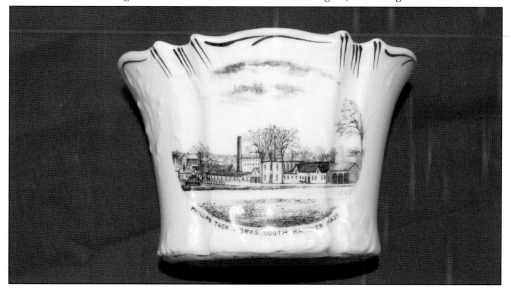

Image negatives were sent to Germany, where a special film was used to create halftone images on small china pieces that were sold in Thomas Drew's store. The tack factory pictured on this small bowl was located across the street from the Drew store.

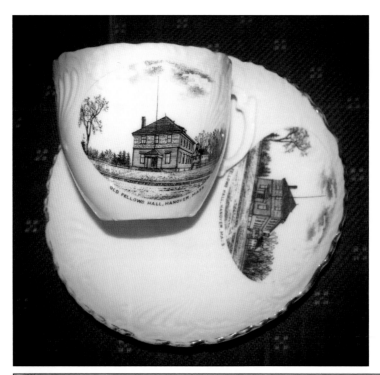

This is another of the handful of images printed on souvenir china for sale in the Drew store. The maker did not get this one quite right, calling Hanover's Odd Fellows Hall "Old Fellows Hall."

AMERICAN PHOTOGRAPHY

221 COLUMBUS AVE., BOSTON, MASS.

ENTERED AS SECOND-CLASS MATTER
AT BOSTON, MASS.

NOV 1912 4
THOMAS DREW
BOX 78
SOUTH HANOVER MASS

Thomas Drew took his hobby seriously, and this 1912 envelope proves that he was subscribing to *American Photography* magazine. This monthly magazine, published in Boston, began in 1907 and was intended for amateur photographers.

Two

HALIFAX

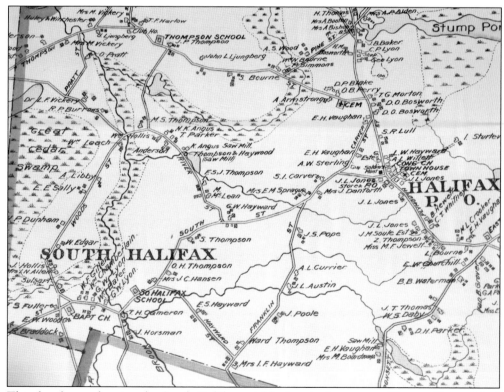

This detail map showing the South Halifax neighborhood where young Thomas Drew visited his grandfather's farm is from the 1903 *Plymouth County Atlas*.

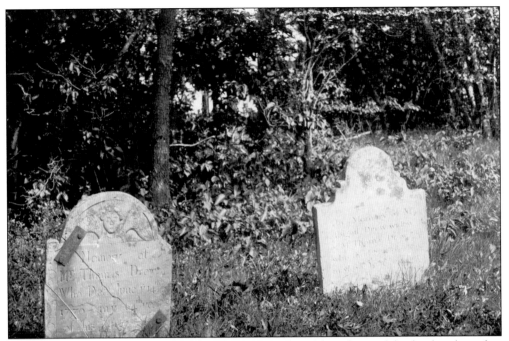

Thomas Drew, great-great-grandfather and the namesake of the subject of this book, is buried in the Thompson Cemetery on Thompson Street. His headstone still looks much as it did in this photograph taken over 100 years ago. The iron plate repair has lasted well!

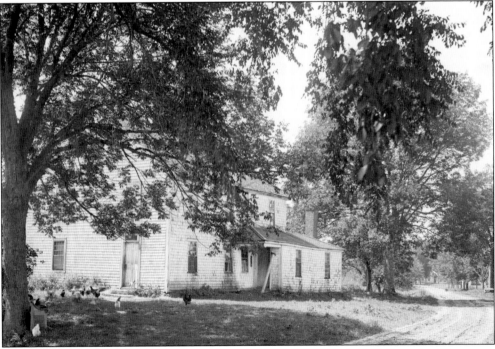

Thomas Drew wrote, "The George Drew House in Halifax MA was built by Barnabus Thompson about the time of his marriage in 1740." He also noted that the family was very fond of their elm trees. Young Tom no doubt spent many happy days at his grandfather's farm.

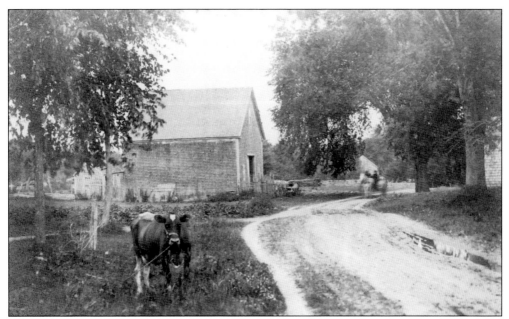

A horse cart is in motion as it passes the George Drew farm, while a milk cow warily watches the photographer capturing the scene. The Drew farm was on River Street in Halifax close to the Middleboro town line.

The weathered shingles and broken windows show a farm that is in decline. Grandpa George Drew died in 1866, and this photograph was taken many years after that. Grandma Sarah Drew lived to the ripe old age of 101, passing away in 1886. The free-range chickens would have done a great job of keeping insects out of the garden!

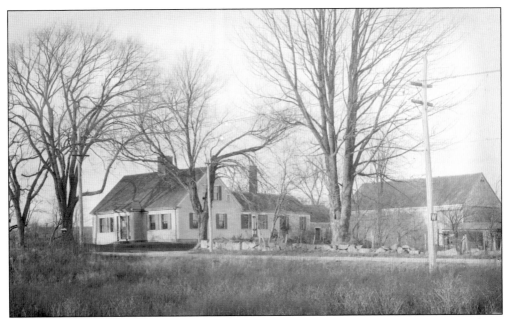

The Zadock Thompson house on River Street was close to the Drew farm. Thompson was born in Halifax in 1747 and died in 1787. His ancestor John Thompson came to this area from Wales in 1622. Zadock began a sawmill on River Street that was operating as Thompson and Haywood Sawmill when Thomas Drew visited his grandfather. K. Angus also operated a separate sawmill on the street.

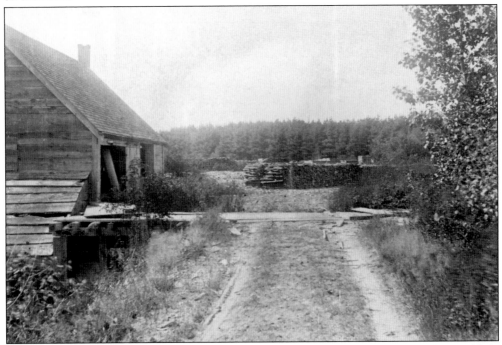

Thomas Drew wrote that he often played at the site of this Halifax sawmill as a child. It is likely that this was the Thompson and Haywood Mill located on River Street in Halifax just down the road from his grandfather George's house.

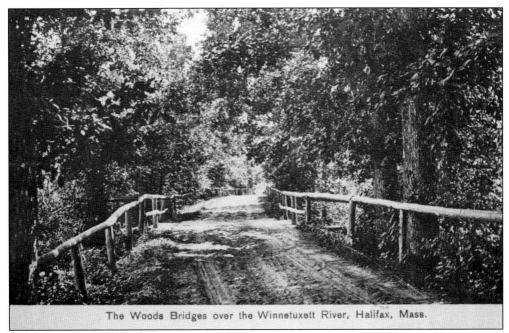

The Woods Bridges over the Winnetuxett River, Halifax, Mass.

This Thomas Drew postcard image shows the bridge over the Winnetuxett River in Halifax. This bridge was on River Street, close to the house of Thomas's grandfather George. The Town of Halifax and the Wildlands Trust have created almost 250 acres of nature preserve along this river, so it remains today as it was when young Tom Drew enjoyed it. (Courtesy of Halifax Historical Society Museum.)

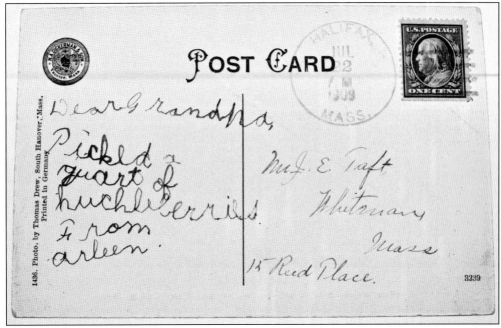

The back of the card in the previous image shows that this Thomas Drew photograph postcard was printed in Germany for H.A. Dickerman & Son of Taunton, Massachusetts. Grandpa must have been pleased with Arleen's industriousness. (Courtesy of Halifax Historical Society Museum.)

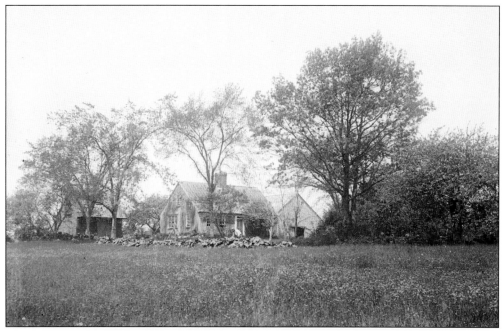

This is another neighbor of George Drew on River Street. This farm appears well to do with its two outbuildings. The field is bordered by a stone wall, which is less common in Halifax than in other South Shore towns, courtesy of the glaciers that left finer deposits here.

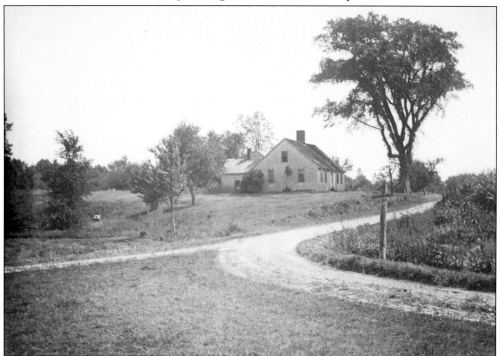

Just a short distance west of George Drew's house, a towering elm tree stands watch over a Cape Cod–style home on River Street at the corner of Wood Street in Halifax. The street sign points south to the Bridgewaters.

This antique Cape Cod–style home on the bend in the road on Pond Street in Halifax has the typical apple tree in the yard and a well right outside the back door.

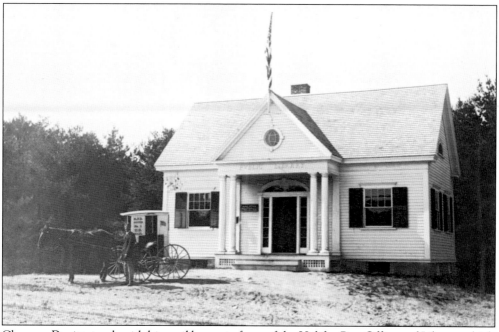

Clarence Devitt stands with his mail buggy in front of the Halifax Post Office and Library, which is now home to the Halifax Historical Society Museum. The J. Levering Jones family donated this former schoolhouse from South Halifax to the town. It was moved and initially used as both a library and a post office. This view was used in a Kruxo postcard now in the collection of the museum.

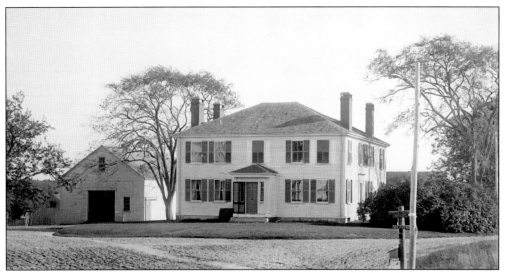

Pope's Tavern was built in 1820 in Halifax as a wedding gift for new bride Lydia Sturtevant Pope. It was a popular gathering spot visited by Daniel Webster and was the site of former president John Quincy Adams's nomination to serve in Congress in 1830. It now houses the Halifax Senior Center.

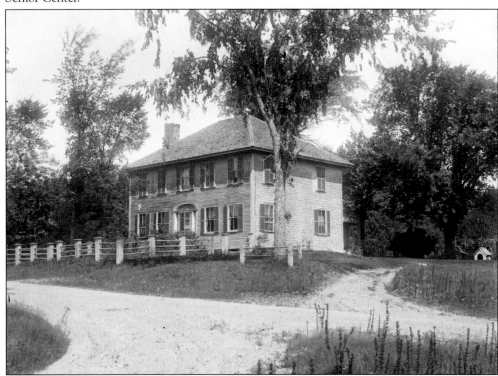

The Dr. Cyrus Morton House on Plymouth Street in Halifax remains today. Dr. Morton was first married to Lucy Drew, who died in childbirth, and he later married her sister Lydia. Lydia was formerly a teacher for Laura Bridgman, a deaf-blind girl who attained fame in the mid-19th century. Bridgman sometimes visited Lydia in Halifax. This house was built by George Drew (1788–1866); Thomas Drew managed to get the backyard doghouse into this photograph.

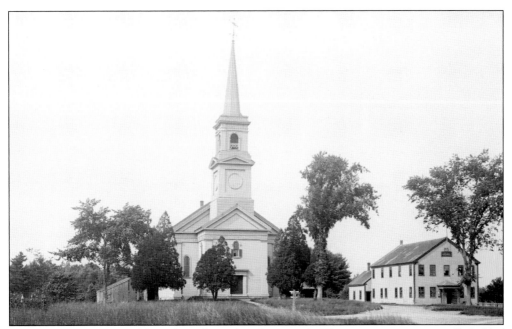

Halifax Town Hall is visible to the right in this photograph. This structure was originally half of the church that was moved to this site in 1852 and used as a town hall, school, and library until it burned down on March 20, 1907. The small addition at the rear was used as an armory. The Halifax First Congregational Church (on the left) was built in 1852.

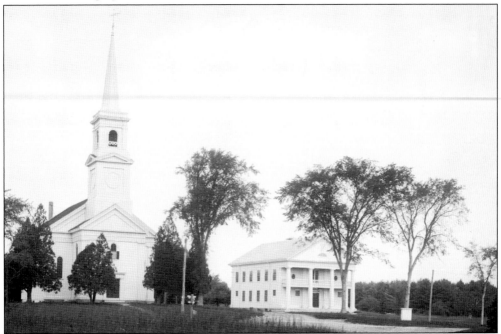

Pictured here are the Halifax First Congregational Church and the new Halifax Town Hall, which was dedicated on December 20, 1907, less than a year after the previous structure was destroyed by fire. The white box in front of town hall is part of the scale used to weigh hay and other products for sale in the town.

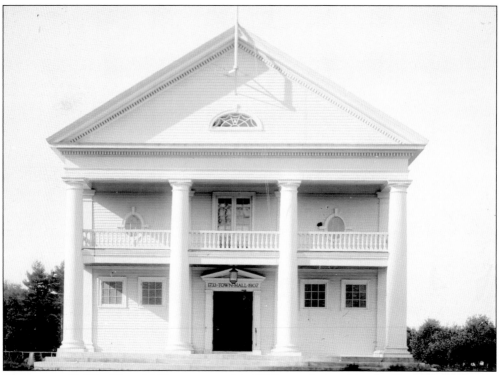

The current Halifax Town Hall, constructed in 1907, was designed in the Greek Revival style. This style, most popular in the United States in the early to mid-19th century, emphasized heavy cornices and classical round columns.

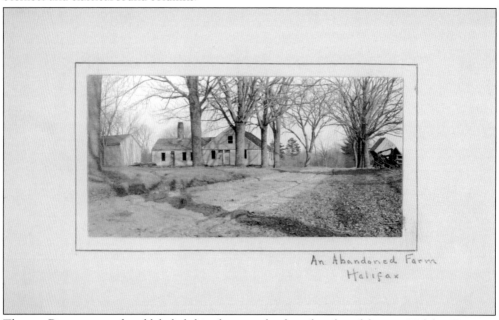

An Abandoned Farm
Halifax

Thomas Drew mounted and labeled this photograph of an abandoned farm in Halifax. Farming was the primary occupation of landowners at this point in time, and various conditions could lead to failure.

Halifax Elementary School now occupies the part of the J. Levering Jones Estate where this mansion once stood. Jones (1851–1920) was a Philadelphia native who was a prominent corporate attorney. His 75-acre Halifax summer estate was later used by the Standish Manor School, a boarding school for girls with special needs. The Town of Halifax eventually purchased the land, and the elementary school was constructed in 1960. This property was originally part of 700 acres owned by Myles Standish, including 10,000 feet of lakefront property and 100 acres that were farmed.

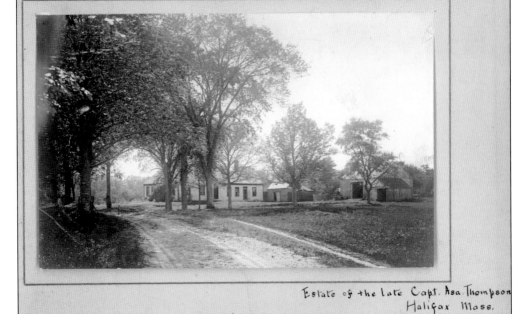

Estate of the late Capt. Asa Thompson
Halifax Mass.

This shows an original Thomas Drew matted photograph of the Asa Thompson house. Thompson, who stood six feet and six inches in height, was called the "Tall Captain." He led the Halifax militia company—the oldest in the state—during the War of 1812, defending coastal communities from English attacks. Asa's wife, Hannah, was the sister of George Drew's wife, Sarah.

A well taken and developed 8-by-10-inch glass plate negative produces high-resolution photographs that appear equal to (or better than) the output of many 21st-century cameras. This detailed image was made from the glass plate used to create the preceding photograph of the Asa Thompson home.

Three

HANSON

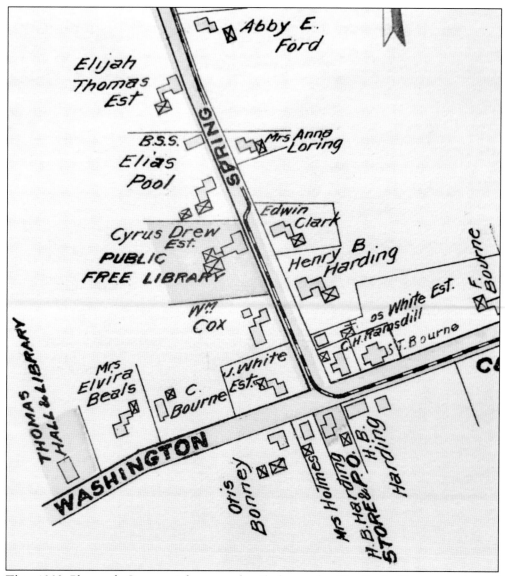

This 1903 *Plymouth County Atlas* map detail shows the Harding's Corner section of Hanson, Massachusetts.

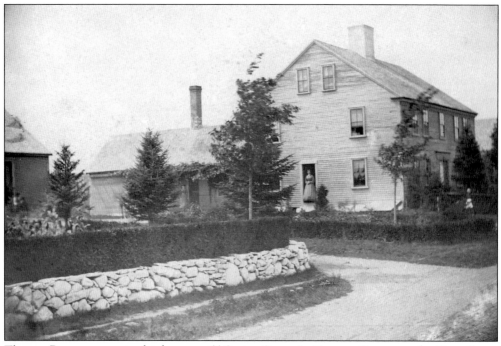

Thomas Drew grew up in this house at 55 Spring Street in Hanson. Known as the Drew-Soper house, it was built around 1797 by Isaac Soper. Cyrus Drew purchased the house in 1857, when Thomas was 12 years old. Cyrus operated his store in a barn here, and his daughter Mary maintained a lending library on the property. This picture shows four or five members of the Drew family.

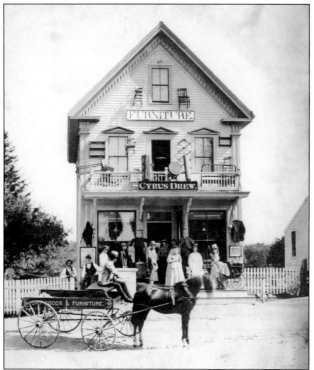

Thomas Drew learned the trade of storekeeper by helping his father operate the Cyrus Drew Store on Willow Street (now Washington Street) just down the street from the Drew home (which was on Spring Street). Clearly, furniture was a big seller at this store! Could that be young Tom driving the delivery wagon?

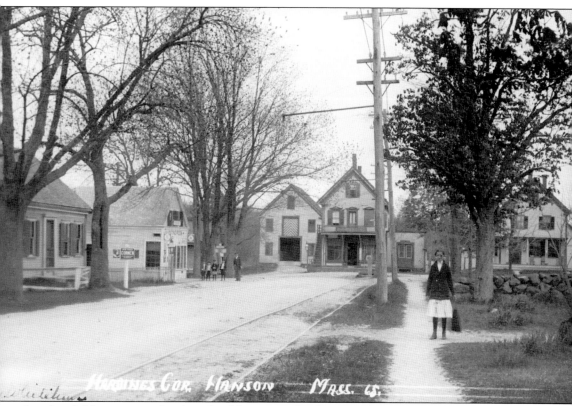

HARDINGS COR. HANSON MASS. 65.

Are the children waiting for the school barge to take them to school, or are they posing for Thomas Drew (or both)? The trolley tracks run down to Harding's Corner, where the Henry B. Harding store is open for business. The Harding store replaced Cyrus Drew at this location when he moved his store to his home. The trolley waiting room is visible on the left where the children are standing. The building to the right of the store is the town clerk's office, which can be seen in detail on the next page. The chairs are in the same position on the porch in both photographs, so perhaps Drew took both on the same day.

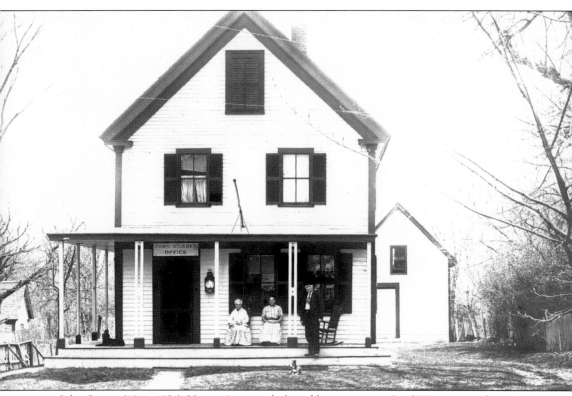

John Scates (1841–1931), Hanson's town clerk and last surviving Civil War veteran from Hanson (Company G, 1st Mass. Infantry), stands outside his office on Washington Street. Scates bought a farm in Hanson in 1885 and was active in the community thereafter. A widower, he married Lucy Holmes (b. 1840) on December 17, 1902. Lucy is likely the older lady sitting on the porch of the office, which was also their home. John became town clerk and treasurer in March 1903, and was commander of the Theodore L. Bonney GAR Post 127 for 19 years beginning in 1904.

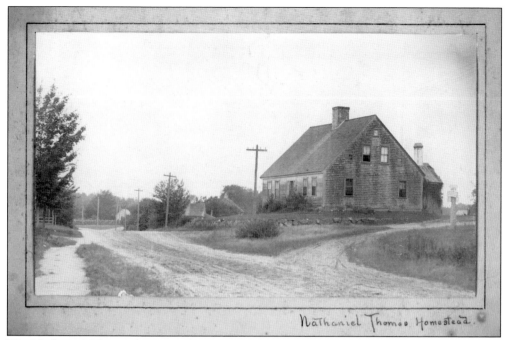

Nathaniel Thomas Homestead.

The Nathaniel Thomas homestead was located at 527 Liberty Street on the corner of Winter Street. Built in 1760, the house was moved 300 feet west when the road was reconstructed in 1930. It was demolished in 1968, when a Sunoco station was built on the site.

The Cape Cod–style house and large barn at 357 Liberty Street was built around 1820 by Charles Howland. Located opposite Shaw's Market, it has been occupied by the Leverone family for many years.

Flavel S. Thomas MD, LLD, began his medical practice in 1879; in 1894, he began operating Maquan Sanitarium (shown here on the left) at 149 Maquan Street in South Hanson. An advertisement in the October 1912 volume (Volume 40) of *Medical Times* describes the sanitarium: "A Health House and Sleeping Shack. High, dry location, in a pine grove, southern exposure. Fresh, dry, pure air, plenty of sunlight, nature's remedies for consumption and other chronic diseases."

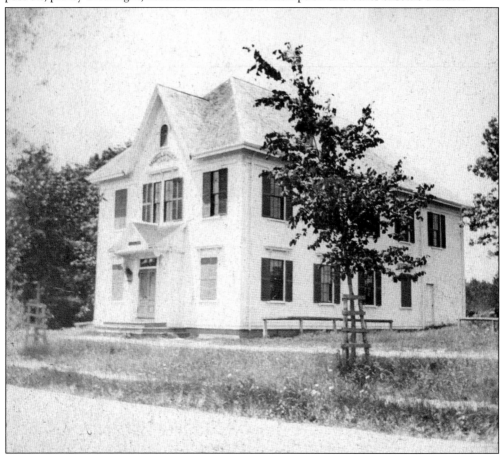

Thomas Hall, erected in 1884, was the location of a library incorporated as the Hanson Library Association. Evie Drew was the librarian and was taking care of more than 1,500 volumes on the first floor by 1902. The second floor was used as a hall for plays, musical performances, and other social events. The building burned in 1991.

One street sign at State Street and Washington Street in Hanson points west to East Bridgewater (8 miles) and east to Pembroke (2 miles). Another directs the traveler 2 miles north to Hanover or 15 miles south to Plymouth.

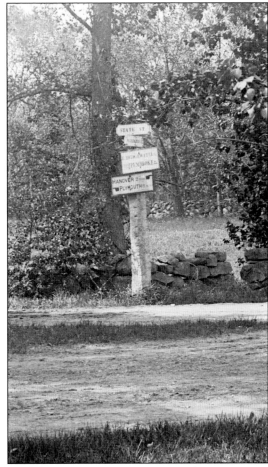

According to the *History of Houses in Hanson* (1932), the Monroe Place, located at 503 Elm Street and also known as the Thaddeus Howard Place, was built between 1800 and 1805 by "one Hathaway and sold to Captain Cyrus Monroe in 1837." A visit to 503 Elm Street in 2017 reveals that the distinctive granite posts and the well remain in place.

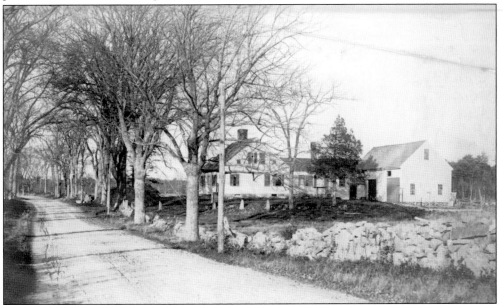

Joseph White's *History of Houses in Hanson* (1932) notes that the William Bourne Sr. family "lived opposite the Town Hall in No. 27 Plan No. 6." This image was labeled by Thomas Drew as "Wm. Bourne house Liberty Street." This was opposite the current location of a McDonald's.

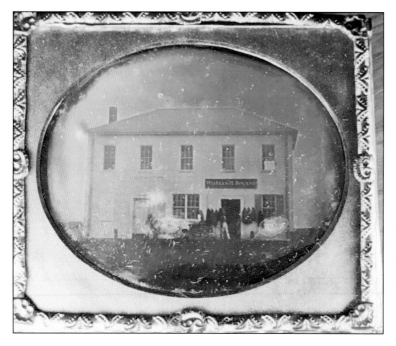

The building shown in this early daguerreotype was built by William Bourne Sr. just east of the current Hanson Town Hall. In 1830, the first floor was occupied by a store operated by Lemuel Hatch, while the second floor was known as Bourne's Hall. The store was operated by Andrew and George T. Bowker from 1856 until 1863 or 1864, when it burned.

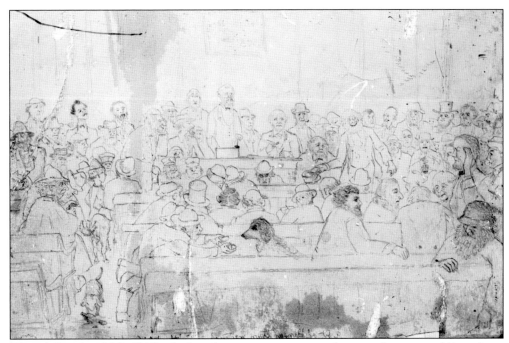

Edgar A. Josselyn (1861–1943), who later became a prominent architect and artist, would have been age 14 or younger when he made this satirical sketch of a Hanson town meeting. In an interview, his daughter Martha noted that "when he was young he made sketches to sell at fairs."

The Josiah Cushing house on Indian Head Street, built in 1763, was the Hanson almshouse from 1837 until 1902. The sign over the door reads "Sunny Side Cottage," and when the photograph was taken sometime after 1902, the Gordon Rest, a vacation home for women, was operating it. This location is now the site of Sullivan Funeral Home.

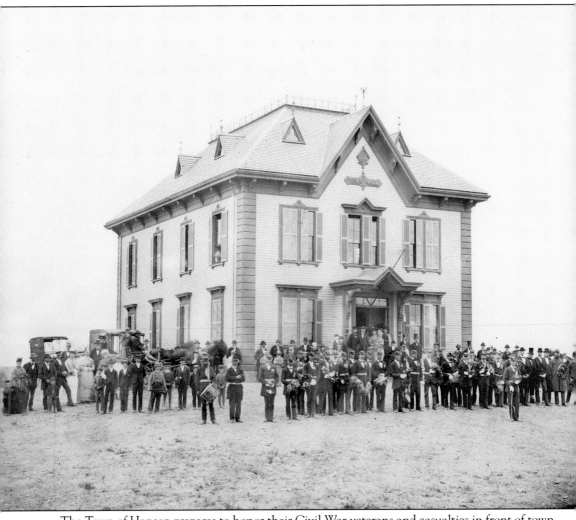

The Town of Hanson prepares to honor their Civil War veterans and casualties in front of town hall. Grand Army of the Republic veterans stand ready to place wreaths and flowers as onlookers dressed in their Sunday best respectfully watch. This photograph was taken before 1906, which was when the Civil War monument was erected.

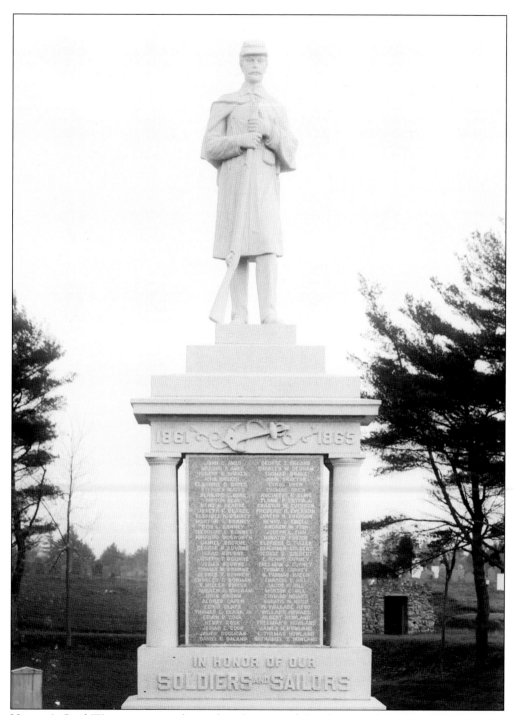

Hanson's Civil War monument, located at the time of the photograph in Fern Hill Cemetery (note the tomb visible in the background), was dedicated on October 20, 1906, and records the names of all Hanson Civil War veterans—not just those who died. The primary inscription reads, "1861–1865, In Honor of Our Soldiers and Sailors." The monument was moved next to town hall on Liberty Street in 1925.

E.Y. Perry was born in this house on Brook Street on October 4, 1812. His mother died when he was six weeks old, and his father died two years later, so he was raised by his grandparents. Perry went on to become a wealthy entrepreneur, founder of the Hanover Branch Railroad, and owner of the block in which Thomas Drew had his store.

This grand old Colonial has been located in four different towns: Abington, Hanover, Pembroke, and Hanson (its current locale). Although the house has never moved, the town boundaries have. Built in 1724 at the corner of Liberty and Washington Streets, the Elijah Cushing house remains one of Hanson's prominent landmarks.

Maj. Eleazer Hamlin (1732–1807), a Revolutionary War veteran, built the home at 131 Holmes Street in Hanson in 1752 and lived there for about 20 years with his wife, Lydia, and their 17 children, including four sons named Asia, Africa, Europe, and America. Eleazer was the grandfather of Hannibal Hamlin (1809–1881) who served as vice president of the United States under Abraham Lincoln.

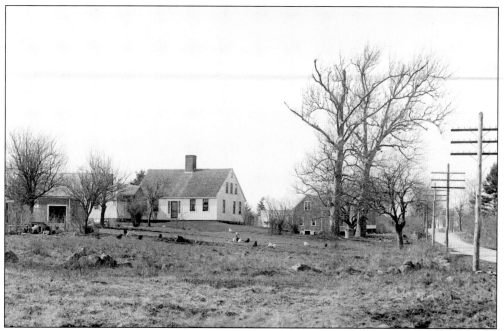

The buttonwood trees in front of this King Street house in Hanson are still there today. The Nahum Stetson house was built in the late 1600s. The trees are a little younger, having been planted on June 17, 1775, the day of the Battle of Bunker Hill.

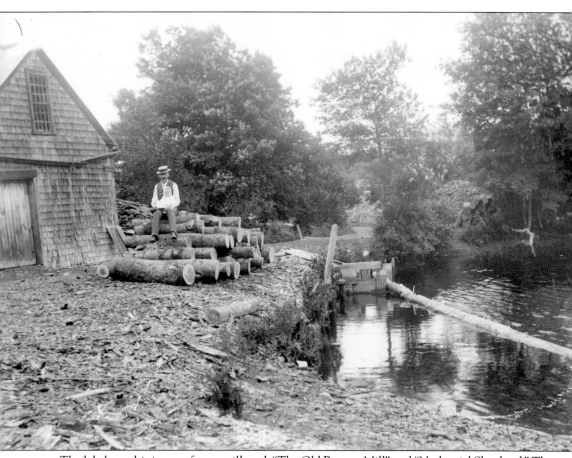

The labels on this image of a sawmill read, "The Old Bourne Mill" and "Nathaniel Shepherd." The 1867 *Plymouth County Directory* lists a William Bourne as having a sawmill in Hanson. In 1712, Josiah Bourne purchased a large tract in South Hanson next to the Great Cedar Swamp. What was later called Burrage was known as Bournetown until 1900. All the land from the railroad tracks to the pond was owned by Charles Bourne, and the business of this area was cutting cedar trees for use as posts, rails and shingles.

Four

SCITUATE

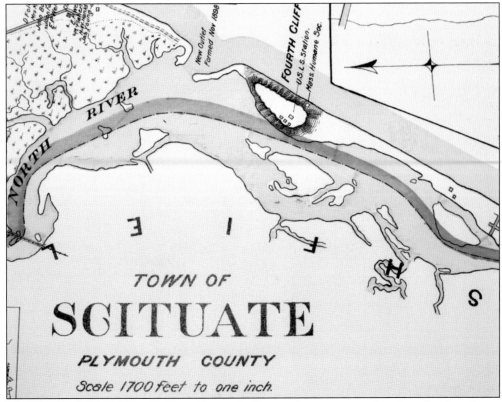

Scituate, one of the oldest towns in Plymouth County, has an ocean shoreline that has always attracted summer residents but has also been the site of many shipwrecks through the years. This map detail from the 1903 *Plymouth County Atlas* shows the Fourth Cliff area where the *Helena* shipwreck took place.

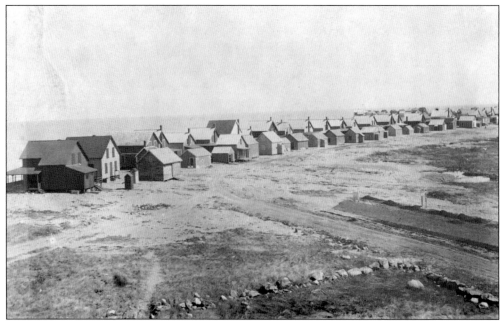

The Humarock section of Scituate is a barrier beach running south from Fourth Cliff with its only land access from the Seaview section of Marshfield. Prior to the storm of 1898, which changed the mouth of the North River, it was connected to the rest of Scituate.

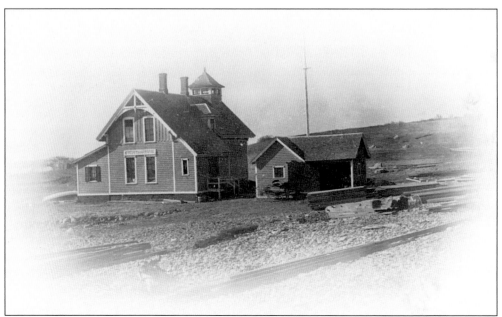

The Fourth Cliff Life-Saving Station was built in 1879 and commanded by Capt. Fred Stanley for many years. Those manning the station worked to rescue seamen in distress until the station burned in 1919. The US Lifesaving Service formed in 1848 and was succeeded by the US Coast Guard in 1915.

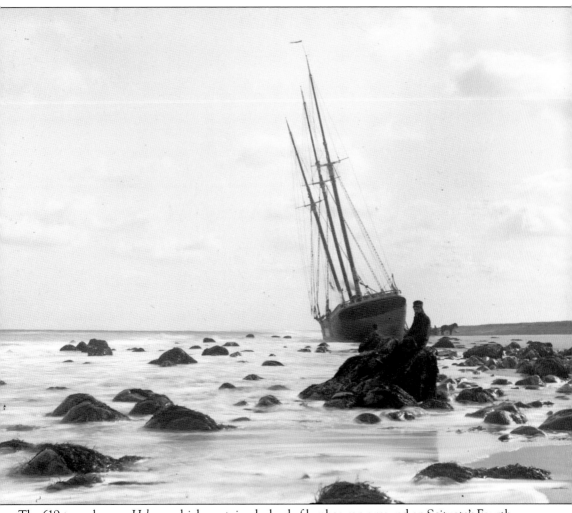

The 619-ton schooner *Helena*, which contained a load of lumber, ran aground on Scituate's Fourth Cliff beach early in the morning on January 30, 1909. Keeper Frederick Stanley and men from the Fourth Cliff Life-Saving Station shot lines to the stricken vessel, and all eight members of the crew were rescued before 11:00 a.m. A headline in the February 1, 1909, edition of the *Boston Post* read "Surfman Saves A Captain." Surfman Carleton dove into the icy waters to rescue *Helena* captain John Cummings, who had slipped off his vessel while trying to remove personal belongings from the ship, which had run aground the day before.

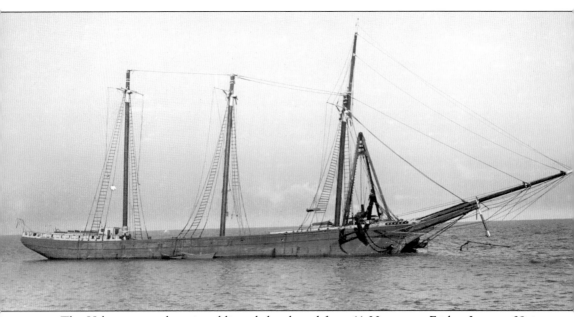

The *Helena* went ashore in a blizzard that lasted from 11:00 p.m. on Friday, January 29, into Saturday, January 30, 1909. Built in Bath, Maine, for New York owners, it was 168 feet long with 38-foot beam, 13-foot draft, and 504-ton net burden.

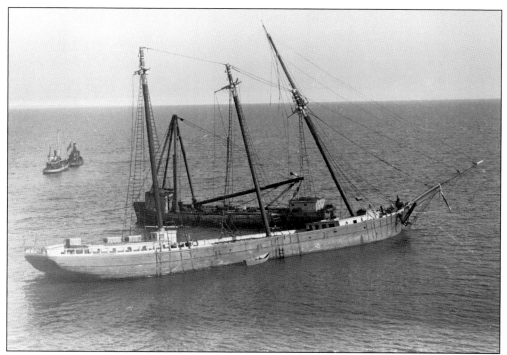

Three salvage vessels from the Boston Towboat Company attempted to pull the *Helena* free at high tide. A salvage boat is visible at the bow attaching lines prior to an attempt to refloat the vessel.

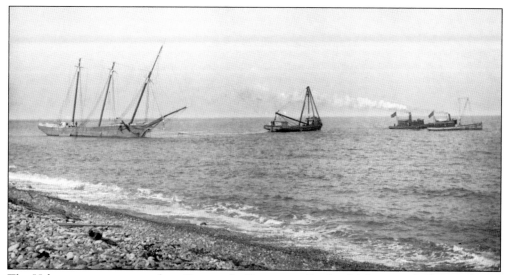

The *Helena* was on a voyage from Savannah, Georgia, to Portland, Maine, with 500,000 feet of southern pine boards when it went aground on Humarock Beach just south of the mouth of the North River. Here, Boston Towboat Company vessels attempt to dislodge the *Helena* at high tide. Their efforts were unsuccessful.

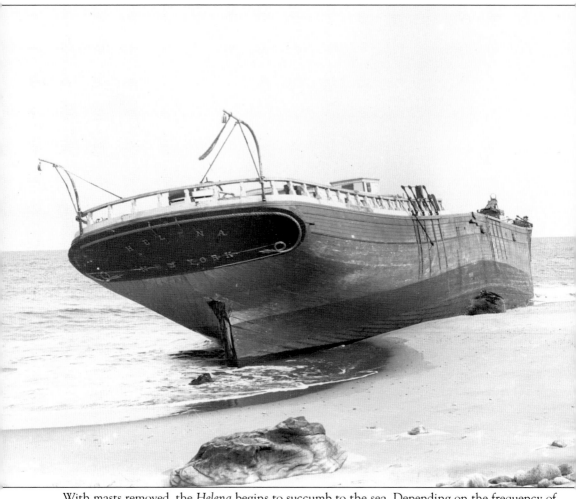

With masts removed, the *Helena* begins to succumb to the sea. Depending on the frequency of storms, it could take years for a wreck to be completely broken apart.

Thomas Drew sits on the remains of a shipwreck. This photograph was probably taken at the same time as the *Helena* grounding, but it must be a previous wreck, as the ocean took some time to break apart the *Helena*.

Sea walls similar to this one line the coastline of the South Shore to protect oceanfront homes from storm surge and destructive waves, but nor'easters often throw debris and stones over the walls—and sometimes destroy waterfront homes.

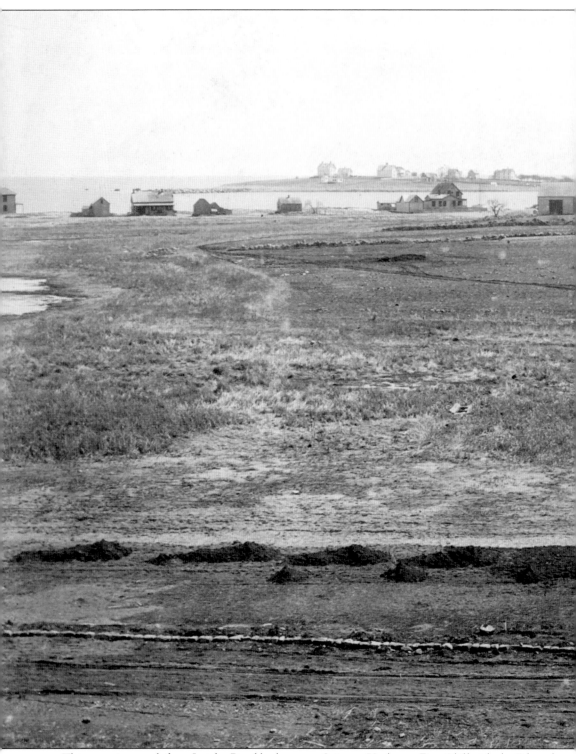

This rare view south from Jericho Road looks across Scituate Harbor to First Cliff with the Edward Foster Road bridge faintly visible at far right. Second Cliff, with its water tower, stands higher to

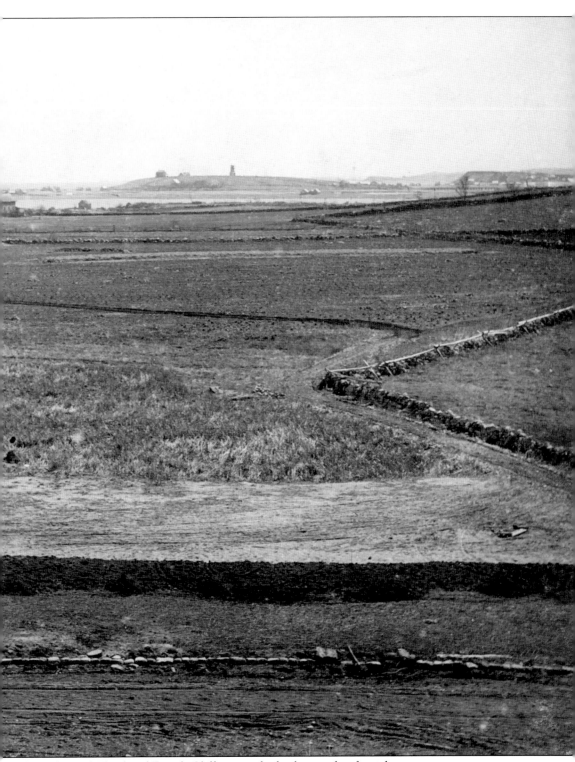

the right, and Third and Fourth Cliffs are in the background at far right.

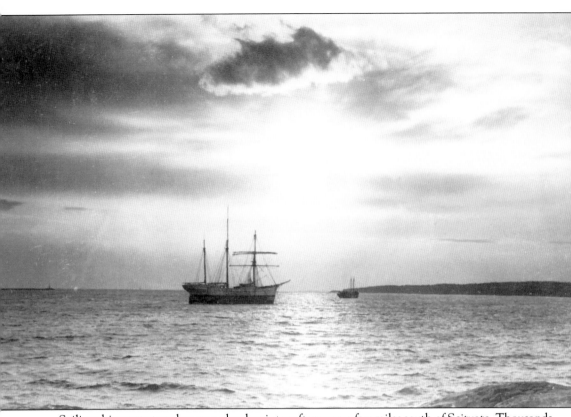

Sailing ships rest at anchor on a cloudy winter afternoon a few miles south of Scituate. Thousands of ships like these were constructed along the South Shore in the 1700s and 1800s, but the age of sailing ships for commerce was coming to a close by the time this photo was taken.

Five

NORWELL

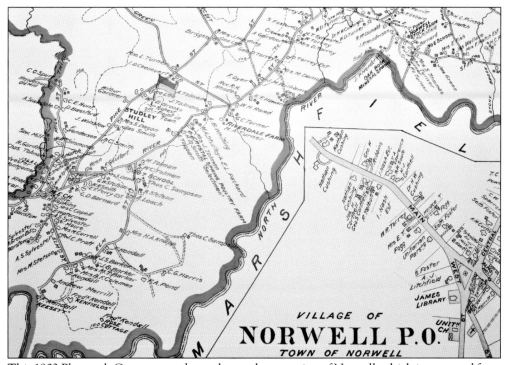

This 1903 Plymouth County map shows the southern section of Norwell, which is separated from Marshfield by the North River.

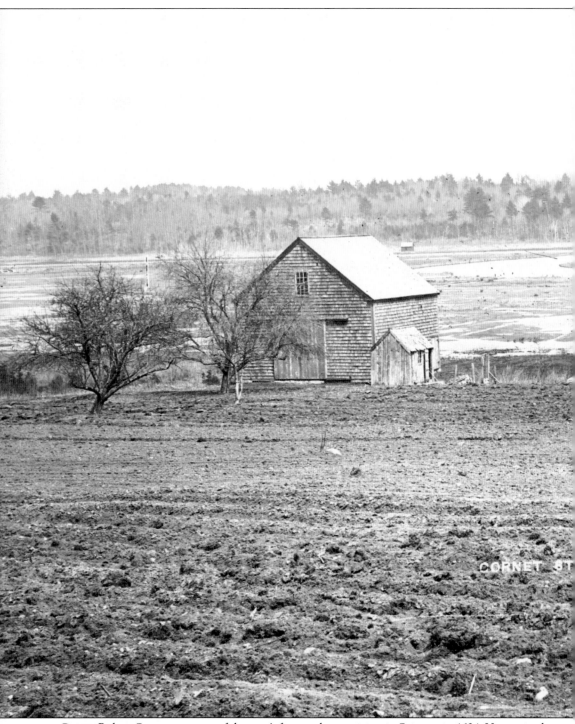

Cornet Robert Stetson was one of the area's first settlers, arriving in Scituate in 1634. He received a land grant for a large tract on the banks of the North River in what is now Norwell, Massachusetts. The furrowed field in the foreground probably indicates this photograph of the Cornet Stetson Plantation was taken in early spring. The Stetson homestead looks out upon the marshes and

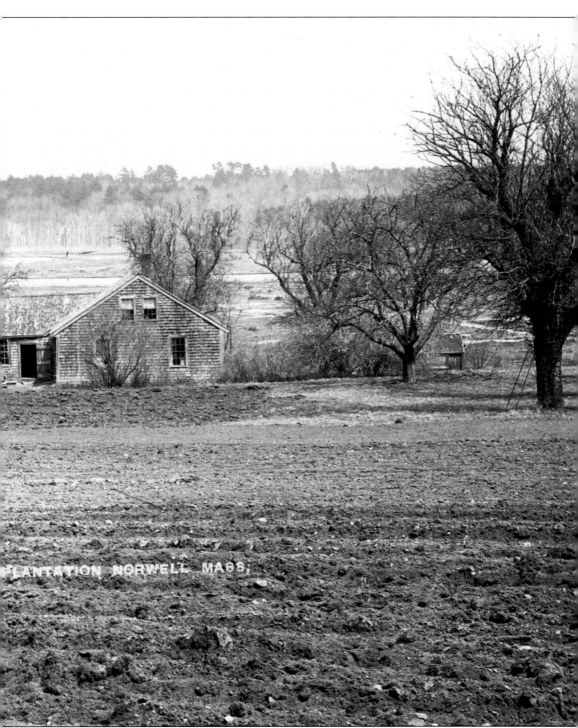

PLANTATION NORWELL MASS,

winding path of the North River. The house shown here replaced the original house, which was demolished around 1769. These buildings no longer exist, but the Stetson Kindred of America, Inc., retains ownership of this beautiful riverfront tract. Across the North River, the Marshfield shore remains undeveloped and looks much the same today.

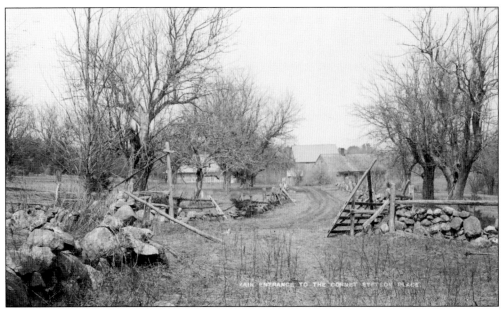

Ancient apple trees flank the entry to what is now called the Stetson Shrine. Before the Stetsons could farm their land, they had to clear the fields of the rocks that ended up forming the many stone walls on the property.

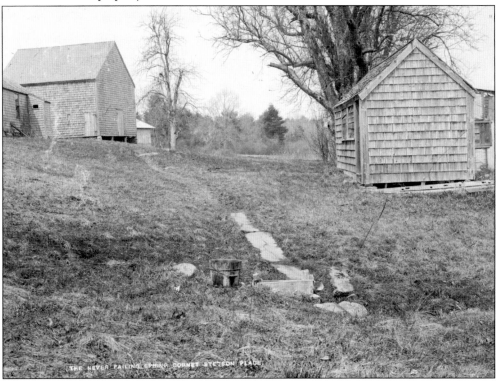

Down the bank behind the Cornet Stetson house was the "never failing spring," which was Stetson's source of fresh water. In this picture taken more than 150 years later, a well-worn path leading to a dipper and bucket indicates that the spring was still flowing.

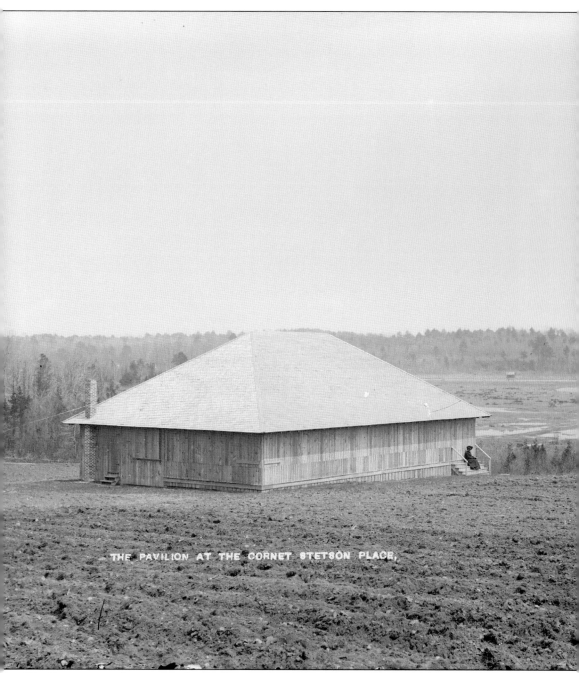

THE PAVILION AT THE CORNET STETSON PLACE,

Ella Drew sits on the steps to the Pavilion at the Cornet Stetson Shrine. Built in 1905 to host a gathering of the Stetson Kindred, the Pavilion has been kept in excellent condition, as the Kindred returns each year to celebrate the family heritage.

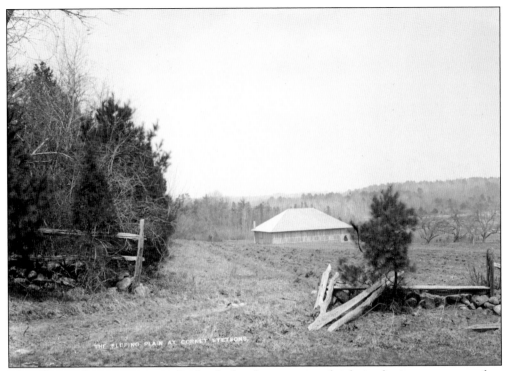

The Thomas Drew pictures in this book that have a printed title in the image were used to make real-photo postcards sold in Drew's store. This view, titled "The Sloping Plain at Cornet Stetson's," has probably made its way into many a Stetson Kindred member's postcard album. A few of the apple trees that were already old when this photograph was taken around 1905 are still living in 2017.

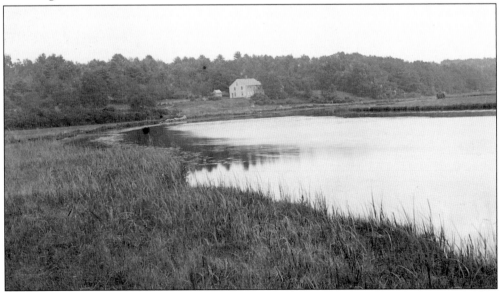

Thomas Drew labeled the sleeve on this scene "the White Place." Nestled into a bend in the North River, this c. 1730 Colonial was owned by Joseph White when this photograph was taken in the early 1900s. The house still stands and is now on Blockhouse Lane in Norwell.

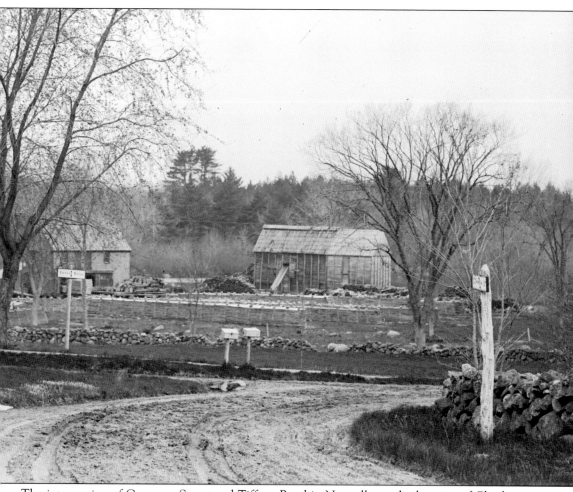

The intersection of Common Street and Tiffany Road in Norwell was the location of Charles Simmons's sawmill (left) and icehouse (right), both constructed around 1888. Before the age of refrigeration, ice was cut from the pond in front of the icehouse in midwinter. Ice blocks were pulled up the ramp into the building, which was insulated with hay. Ice was then delivered to homes during the summer for people to use in their ice chests.

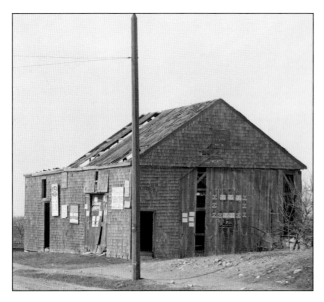

Signs advertising "Howard Clark & Co. 85 Main St. Brockton Sell the best furniture at lowest prices," "Hall & Torrey Hardware, Bank Block, Rockland," "Visit L.W. Orcutt Clothing Hats, Rockland," "Pyles Pearline," and "Besse Baker & Co. Clothier, Brockton" adorn the derelict Halfway House barn at the end of High Street on Washington Street in Norwell. Built by Eliphalet Leonard around 1800 and known as Leonard's Tavern, it was a stopping-off point for Boston-to-Plymouth stagecoaches. This livery stable, which was connected to the hotel, is all that remained after a fire in the 1890s.

Leaving Assinippi Village and heading east on Main Street in Norwell, the Jacobs Mill is visible on the right, Jacobs Pond is on the left, and the Jacobs farmhouse is behind the barn at center left. Thomas Drew was standing in Hanover when taking this picture looking into Norwell. Third Herring Brook, which is the boundary line between the two towns, originates at the pond and flows south to the North River. The grist and sawmill, built by David or Joshua Jacobs around 1730, was destroyed in a fire caused by holiday celebrators on July 4, 1920.

Six

PEMBROKE

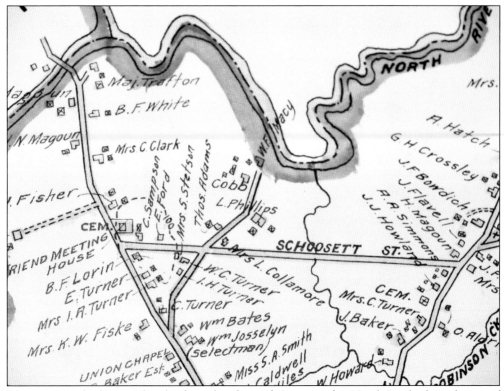

This 1903 Pembroke map detail is from the *Plymouth County Atlas*. North Pembroke is the site of the Quaker (Friends) Meeting House, which remains standing today, as well as the site of several early shipyards, of which nothing remains.

This North River scene was used by Thomas Drew to make postcards. A glass plate negative of the scene was sent to Germany, where a lithographic copy was made and the cards were printed; some were hand-colored. The card printed with this view was titled, "Ship Yard on North River at the Brick Kilns Pembroke Mass."

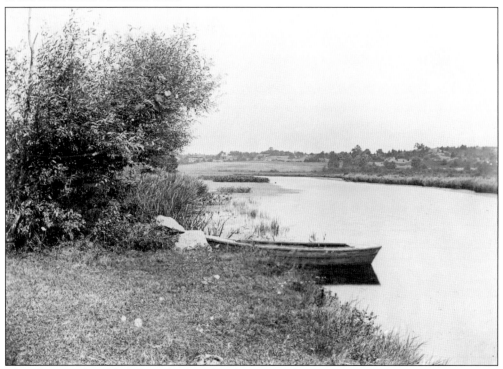

This photograph is labeled "End Of Brick Kiln Lane." Thomas Drew liked to get a boat into his river photographs to provide a focal point. Brick Kiln Lane was the site of Capt. Benjamin Turner's shipyard on the North River beginning around 1730.

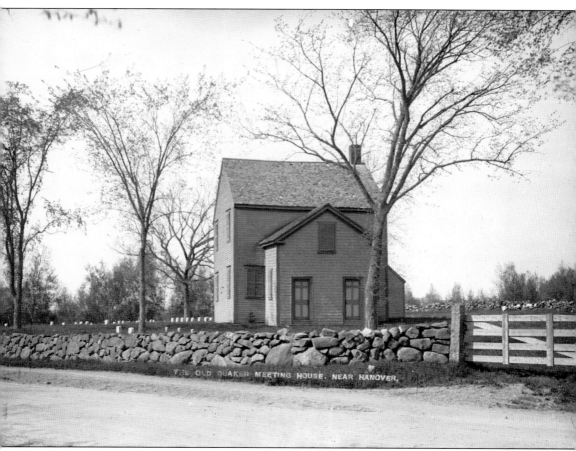

The Quaker Meeting House, built in 1706, stands at the top of a hill up from the North River. The Quaker sect was formed around 1647, and adherents came to the "New World" in the 1650s only to be persecuted by the Puritans governing Massachusetts. Despite hardships, the group flourished in the late 1600s, and the Pembroke meetinghouse was the second on the South Shore.

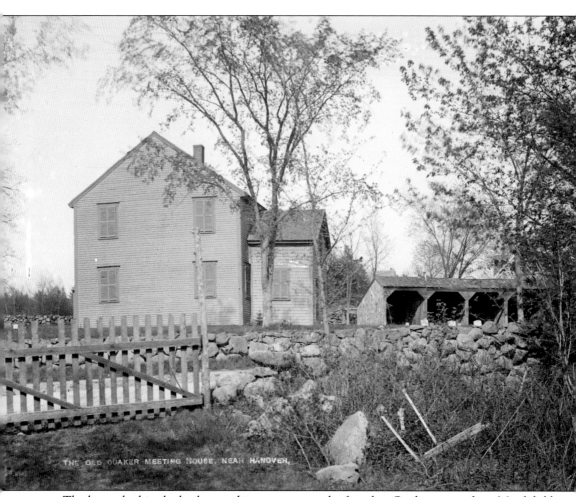

THE OLD QUAKER MEETING HOUSE, NEAR HANOVER,

The horse shed in the background is testament to the fact that Quakers came from Marshfield, Duxbury, Hanover, and other towns to the meetinghouse in North Pembroke. The meetinghouse remains today, along with a burying ground.

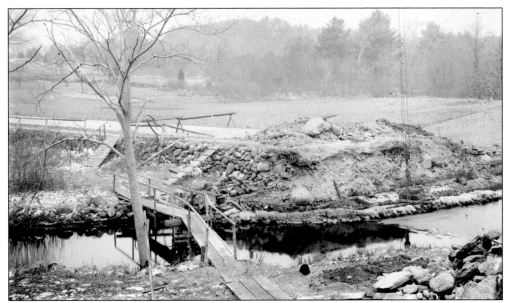

This scene shows a bridge being constructed on Schoosett Street, the road from Pembroke to Marshfield. The street parallels the North River, and Robinson's Creek flows under the road into the river. Across the North River marshes, the Barque Hill area of Norwell is visible.

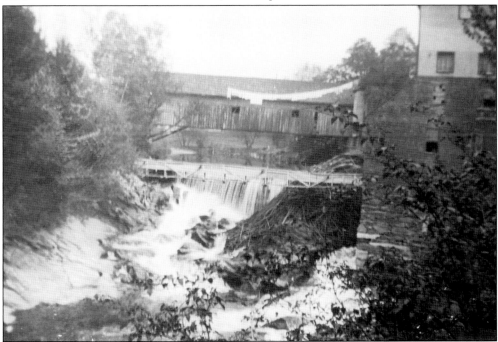

The Eugene Clapp Rubber Mill was first established in 1873 at Luddam's Ford on the Indian Head River. The firm ground rubber items down and recycled the material. When the plant was entirely destroyed by fire in 1881, Clapp built a larger factory, which kept expanding, and by 1886, he occupied large buildings that utilized steam boilers for power on both sides of the river. Later photographs of the factory and bridge over the river exist, but this appears to be an early view of the same site.

The large water tower and buildings of the Clapp Rubber Mill loom over West Elm Street in Pembroke as a cart prepares to cross the bridge at Luddam's Ford on the way to Hanover.

The street sign at the intersection of School Street and Center Street in Pembroke points the way east to Duxbury and west to East Bridgewater. The house rests on a knoll with vast cranberry bogs behind it. The house remains today at 275 School Street, but the bogs have been abandoned and are returning to nature.

This photograph card is signed by M.V. Tillson, who writes that the photograph was taken in 1892. The pitch pine tree at Stetson Pond was a corner boundary marker for 204 acres granted to John Tompson in 1662, so the tree was 230 years old when the photograph was taken. Tillson was noted for his research into early land records and surveys. (Photo by M.V. Tillson, courtesy of Thomas Drew Collection.)

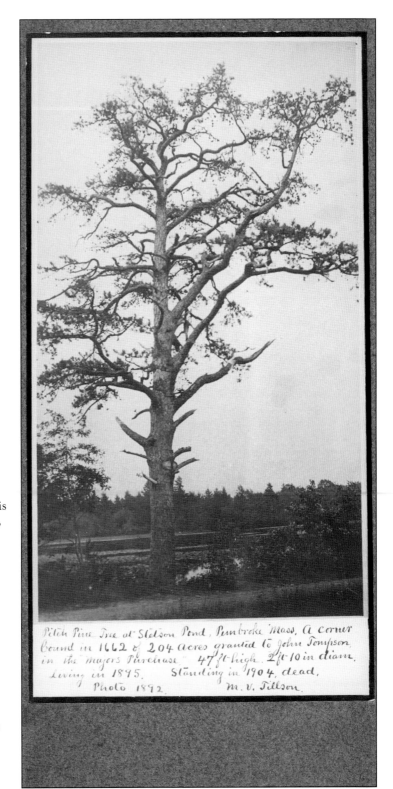

Pitch Pine Tree at Stetson Pond, Pembroke Mass, A corner bound in 1662 of 204 acres granted to John Tompson in the Majors Purchase. 47 ft high. 2 ft 10 in diam. Living in 1895. Standing in 1904, dead. Photo 1892. M. V. Tillson.

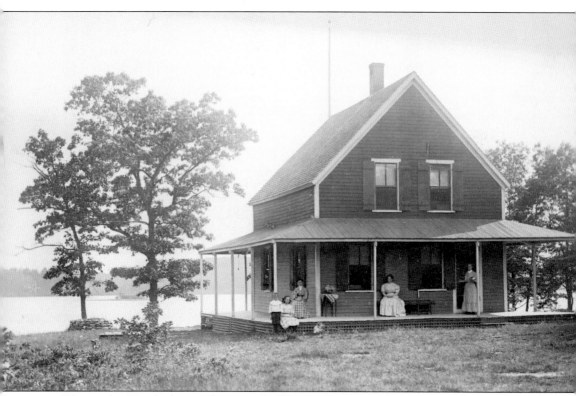

The ponds of Pembroke were home to the Wampanoag Native Americans on their pathway from their summer camps on the seacoast and winter camps in southern New England. In the early 1900s, Oldham Pond, Pembroke's largest recreational pond, was a summer getaway for city folks.

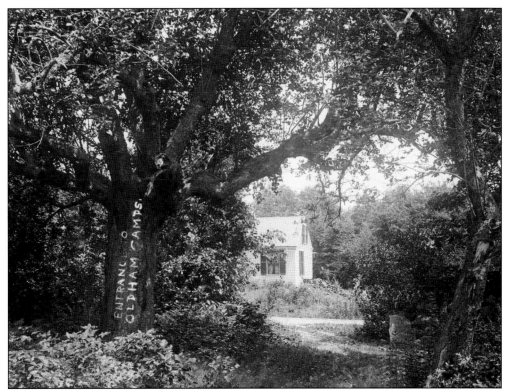

"Entrance to Oldham Camps" is scratched into this glass plate, which was used to make a postcard. Around 1900, there were summer camps on ponds in Pembroke, with some operated by church groups from the city of Quincy. This postcard advertised a camp located on Oldham Street with frontage on Oldham Pond.

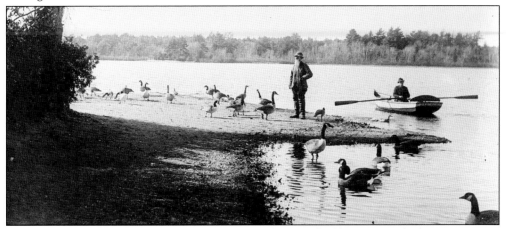

Oldham Pond in Pembroke was a popular location for waterfowl hunting in the late 1800s. Hira "Bill" Bates, the bearded gentleman, gunned for many years from an island camp—so much so that the island was then known as Hira Bates Island. The gunner's blind was nothing fancy but was a popular spot for locals. Records of birds shot were written on the door of the camp, showing 107 geese were shot in 1896 and 60 were shot in 1897. John Phillips bought Baker's Gunning Stand on the eastern shore and the big island in 1905 and Taylor's Point gunning stand shortly thereafter, operating them until 1909, when the area became more filled with cottages.

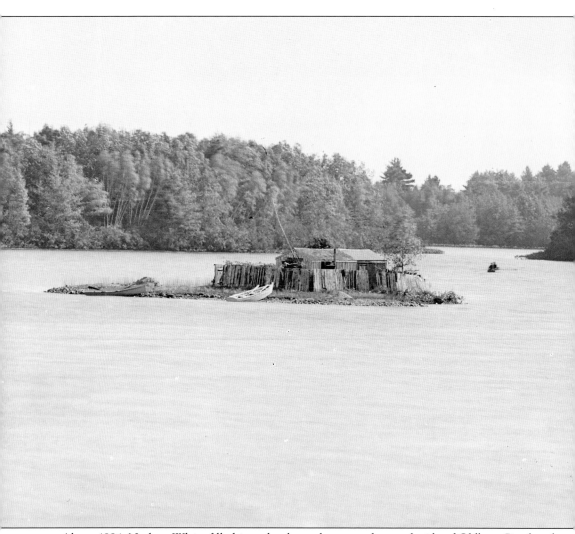

About 1884, Nathan White filled in a shoal area between the north side of Oldham Pond and the island and moved a shack onto it. This place was known as "the Flats," and hunters gunned for geese and ducks from it. This image was made into a color postcard in Germany with the title "Oldham Pond—showing Two Islands and The Flats."

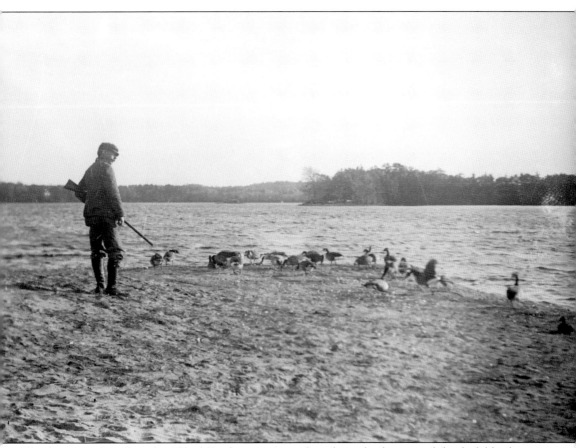

This hunter is thought to be Alfred Gardner, an Accord resident who frequented the duck blinds on Oldham Pond. He looked after the gunning stand at Baker's Point from 1905 to around 1909. The Pembroke ponds were stopping-off points for migratory waterfowl on their way to breeding or winter grounds. The first gunning stand on the pond was established in 1860. Live ducks and geese were used as decoys starting by 1872.

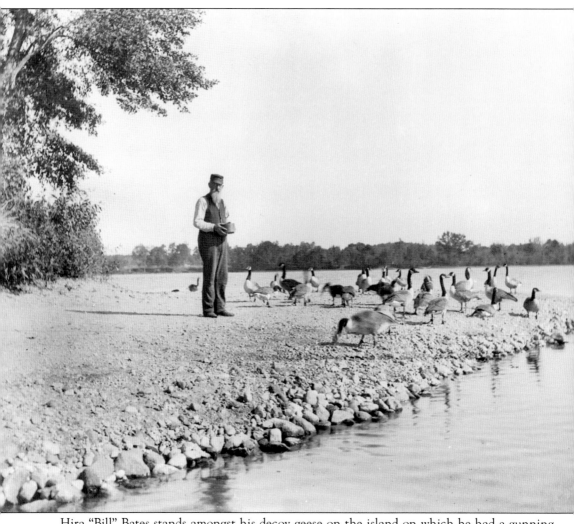

Hira "Bill" Bates stands amongst his decoy geese on the island on which he had a gunning stand. Decoy geese were tame and used to attract their wild cousins that ended up on the dinner table.

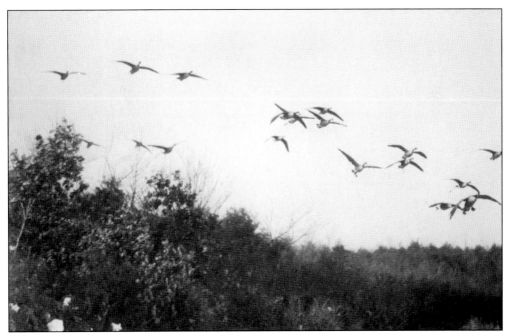

Are these wild geese about to become Hira Bates's next meal? In addition to geese, hunters also gunned for black ducks, mallards, and other species. Hunting is still permitted in Massachusetts, but firearms cannot be discharged within 500 feet of a dwelling, and many ponds are now surrounded by homes.

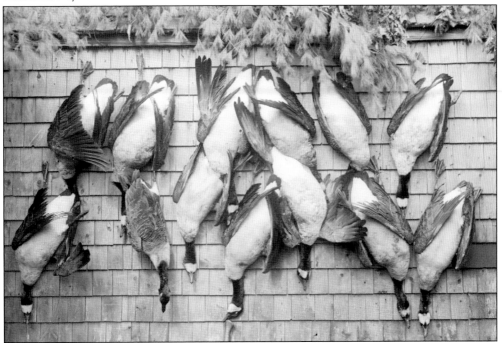

Roasted goose will be on the menu tonight! From the looks of the dangling pine and oak branches, these birds are probably hanging on the side of the duck blind at the end of a successful day of hunting.

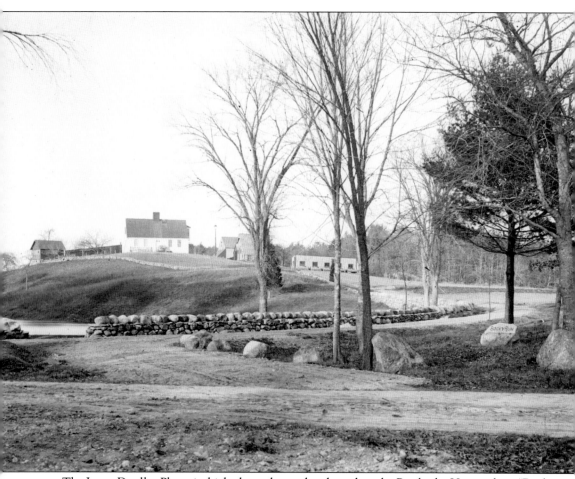

The James Dwelley Place sits high above the road and pond on the Pembroke-Hanson line. "Rocky Run" is painted on a large rock to the right. The headwaters of Rocky Run Brook begin in this section of Pembroke and run north into Indian Head River, becoming part of the boundary between Hanson and Pembroke. Dwelley's name and the date (1857) can still be seen on a granite boulder near where Rocky Run Brook flows into the Indian Head River.

Seven

MARSHFIELD

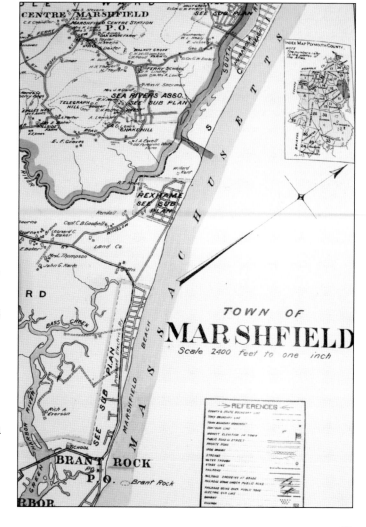

Marshfield, Massachusetts, is aptly named, as there are many marshes along the east and south sections of town. The South River separates the Rexhame village section from the remainder of town, and the Humarock and Fourth Cliff sections of Scituate lie at the end of this peninsula. This detail from a 1903 *Plymouth County Atlas* map shows areas of Brant Rock, Rexhame, and Humarock that are pictured in this chapter.

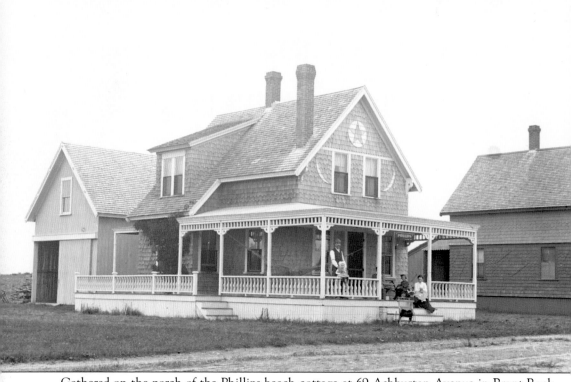

Gathered on the porch of the Phillips beach cottage at 69 Ashburton Avenue in Brant Rock are Fred Phillips (standing); his wife, Jane (Drew) Phillips (seated); and their children, Elizabeth, Evalina, and Lot II. Thomas Drew's wife, Ella, is likely seated behind the post.

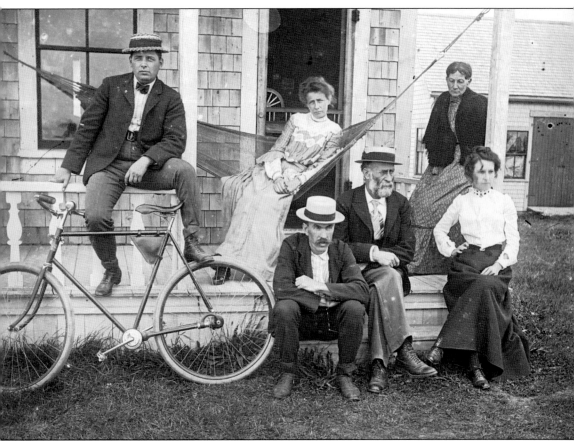

This interesting study of "porch folks" was probably taken at Brant Rock in Marshfield. The bicycle is particularly interesting, as it is a chainless or shaft drive model. These were invented in 1890 and actively marketed by Columbia and other companies in the late 1890s. They did not sell well because they were less efficient and more expensive than chain drive bicycles.

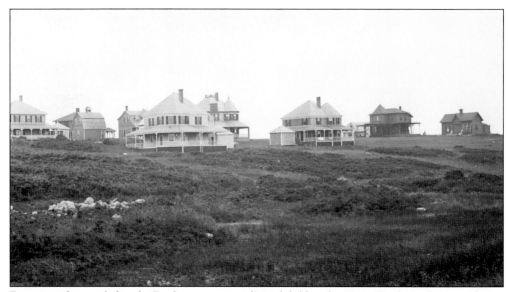

Europeans first settled in the Rexhame section of Marshfield in the 1640s. Rexhame Terrace, shown here, was part of the farm begun by Anthony Thomas in 1753. By the late 1800s, the Thomas family began selling lots, and well-to-do families built large shingle-style summer homes here.

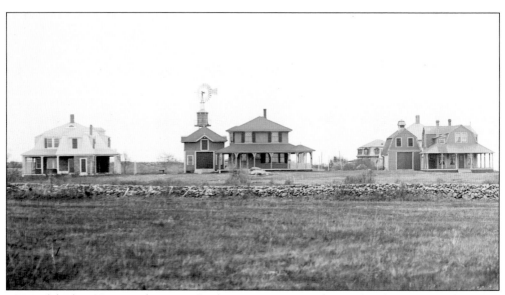

Many of the late Victorian homes in Rexhame Terrace were designed with wraparound porches to take advantage of ocean breezes. The home in the center has diamond-pane windows plus a water tank (and a windmill to keep it full).

An old stone wall and split rail fence separate the growing "cottage" colony on the top of Rexhame Terrace from the Thomas family field. These may be summer folks or Thomas family members stopping to enjoy the ocean breezes.

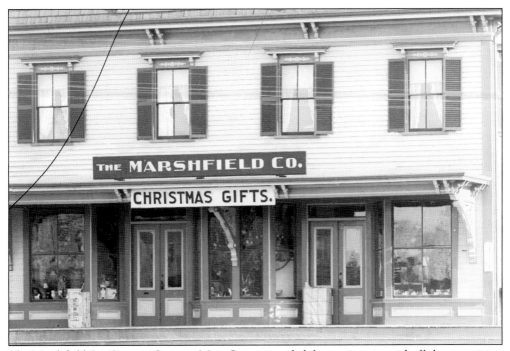

The Marshfield Co. Country Store on Main Street provided the community with all the necessities, including Brunswick food products, in 1910. Their delivery wagon traveled to homes, and at that time they had a phone line to take orders.

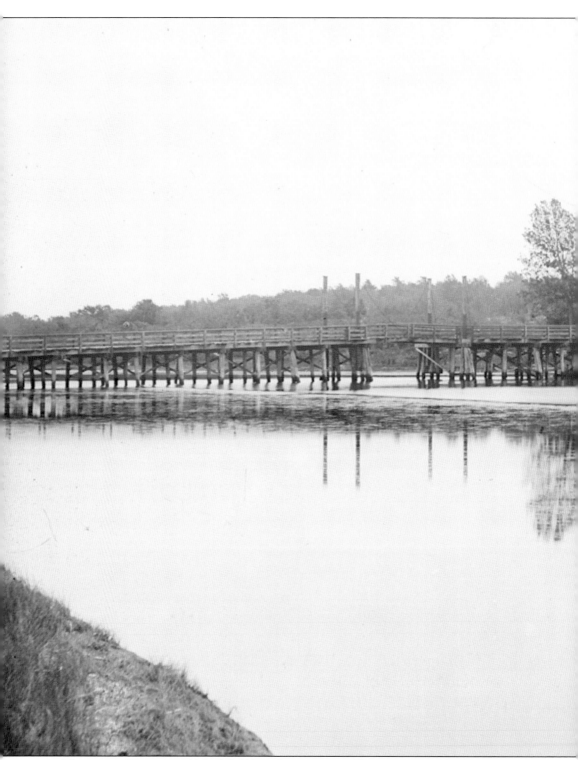

The towns of Scituate and Marshfield have been connected by a Main Street bridge since 1825. The bridge shown here over the North River was built in 1898, just a few years before this photograph

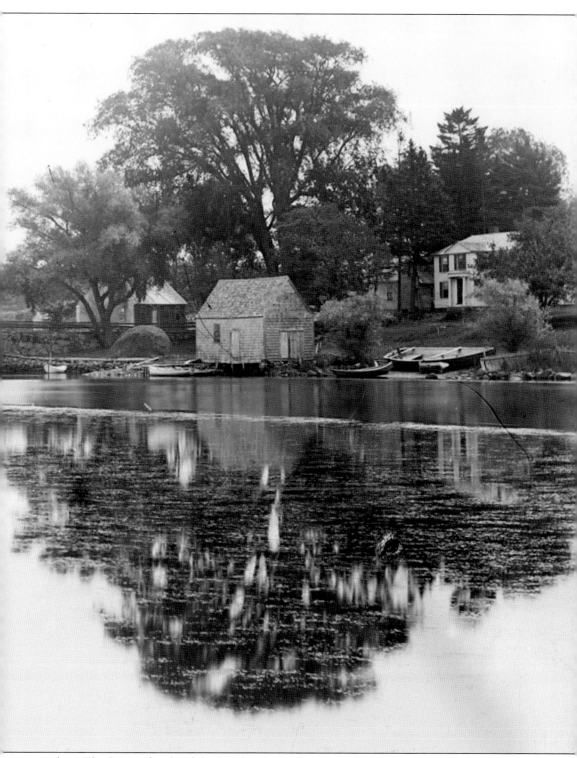

was taken. The Rogers family of shipbuilders lived in the c. 1720 house on the riverbank, and many ships were built in their front yard in the late 1700s.

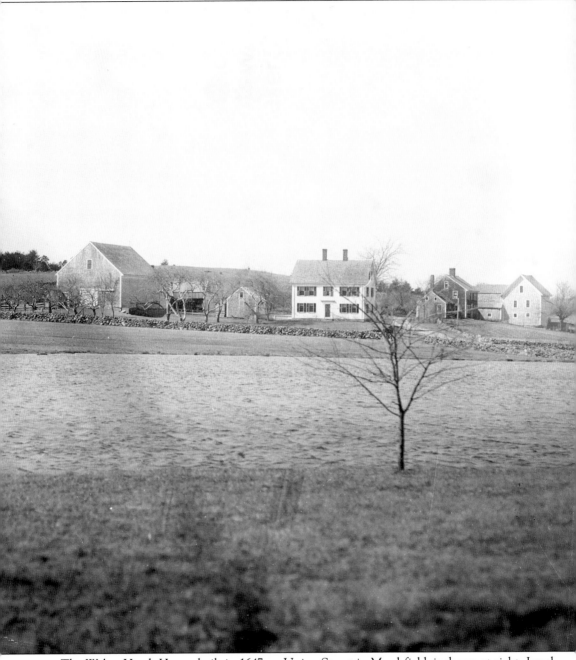

The Walter Hatch House, built in 1647 on Union Street in Marshfield, is shown at right. Israel H. Hatch was in residence there when this photograph was taken. Eight generations of the family lived here before it passed out of the family in 1965. A later Hatch-built Colonial-style home fronts the pond, and an 1812 Hatch sawmill was upstream to the right. Both homes and the restored sawmill exist today.

Eight

A Few Other Stops
along the Way

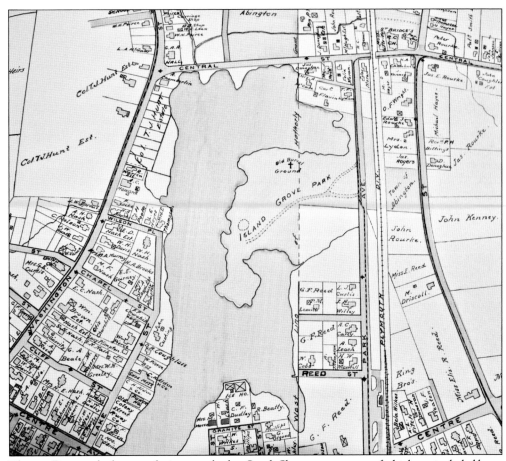

Thomas Drew took photographs in several other South Shore towns, some of which are included here. From south to north, they are Plymouth, Plympton, Kingston, Duxbury, Rockland, and Abington. This detail of a 1903 *Plymouth County Atlas* map shows Island Grove Park in Abington.

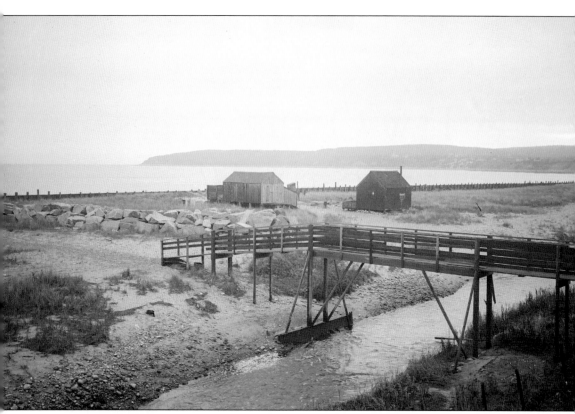

A footbridge takes beachgoers over the Eel River to the barrier beach at Plymouth. Riprap is in place along the beach to minimize storm damage. Eel River is a relatively short (3.9 miles) river that empties into Plymouth Harbor after flowing along the beach for one half-mile. The high land of the Pine Hills is visible in the background.

The National Monument to Our Forefathers in Plymouth, Massachusetts, was dedicated on August 1, 1889. The central figure is Faith, while the other figures are Morality, Law, Education, and Liberty, symbolizing the principles upon which the Pilgrims founded their government.

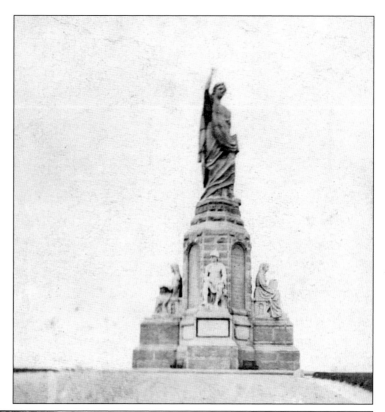

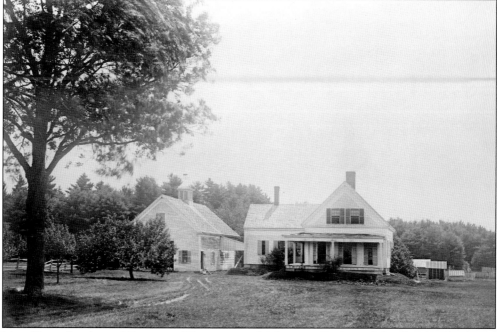

Mary Drew, daughter of George and Lucy, married Adoniram Soule, and they lived in this home in Plympton. Benjamin Soule, grandson of the *Mayflower* Pilgrim George Soule, was one of the first settlers in Plympton.

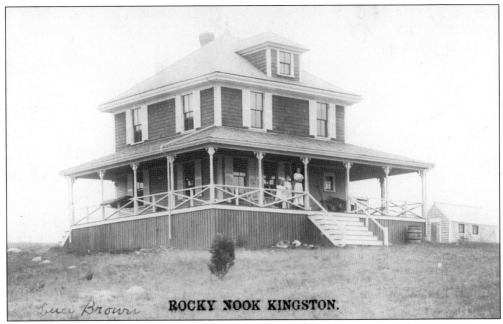

ROCKY NOOK KINGSTON.

A young woman and two young girls stand on the porch in this postcard showing a summer cottage in the Rocky Nook section of Kingston. The young woman may be the "Lucy Brown" whose name is written on the card; Brown was born in Hanover in 1878.

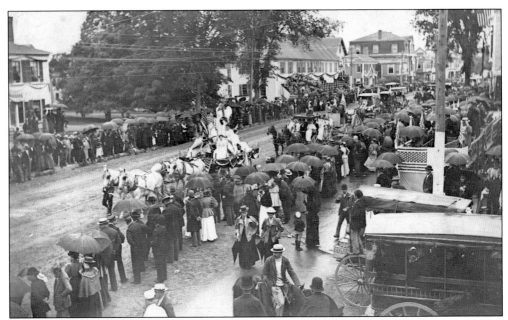

It was a rainy holiday, but the parade went on in Duxbury amid a sea of umbrellas. Four white horses lead this procession with a flag-bedecked float containing ladies dressed in white. Buildings are decorated with bunting, and a large viewing stand is visible across the street.

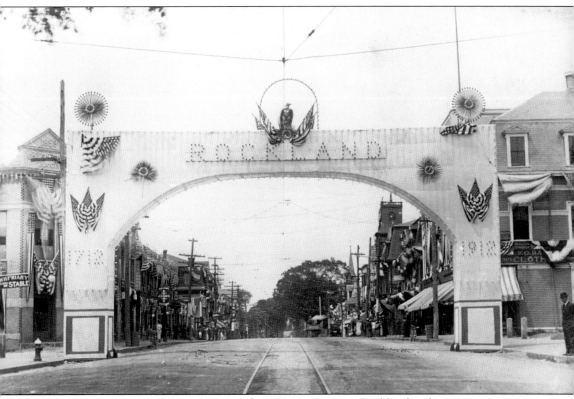

This Thomas Drew postcard image looks north on Union Street in Rockland as the town prepares to celebrate 200 years of incorporation. All the business blocks are decorated with red, white, and blue bunting, and an illuminated arch topped with an eagle spans the town's main street.

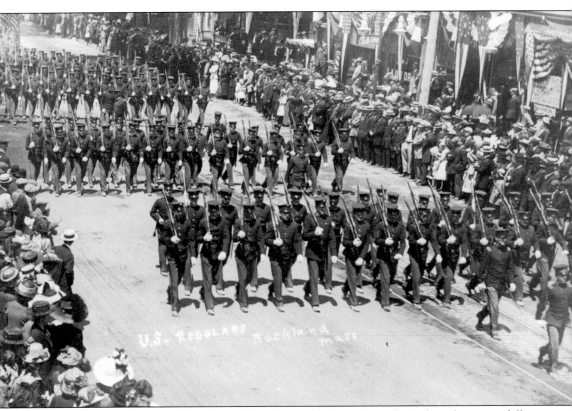

This postcard is labeled "U.S. Regulars Rockland Mass." "Regulars" describe active full-time members of the US Army. Here, they are marching down Union Street in Rockland during the town's bicentennial celebration in 1912.

This photograph is labeled "A Noted Rockland Family," and notes "Dr. Charles Winslow in center with his father. Dr. Julia Drew Winslow the mother also a doctor." Charles was a member of the US Veterinary Medical Association and the owner of trotting horses.

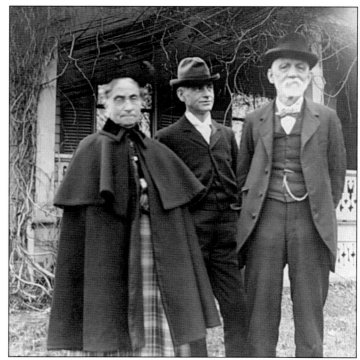

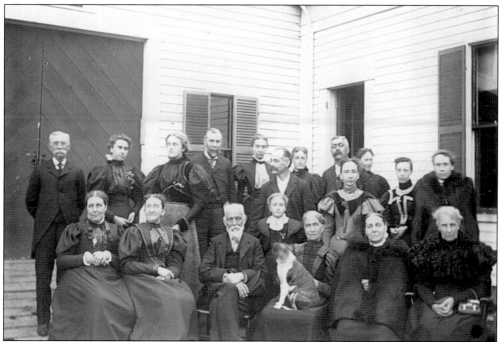

This photograph, probably taken at Dr. Charles Winslow's in Rockland, shows, from right to left, (first row) unidentified, Emma Drew, Lincoln Winslow, unidentified, Dr. Julia Winslow, Abbie Donaldson, and Evalina Donaldson Drew; (second row) Ernest Drew?, unidentified, unidentified, Cephas Drew, unidentified, and Charles Winslow; (third row) unidentified, George Gloss?, Ella J. Drew, Jane Drew (grandmother), and unidentified.

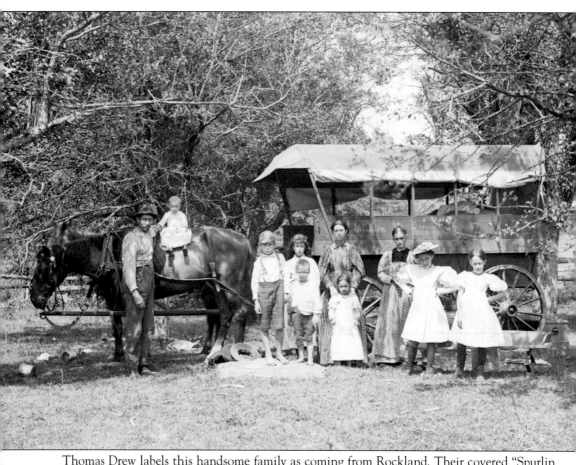

Thomas Drew labels this handsome family as coming from Rockland. Their covered "Spurlin Warranted" wagon is basically the 1900 equivalent of a Chevy Suburban. The kids did a pretty good job of staying still for the slow camera shutter—there is only one blurry face!

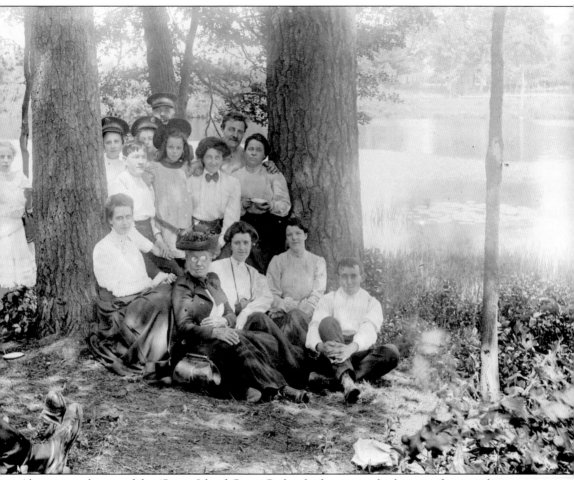

Abington is the site of the 17-acre Island Grove Park, which is a popular location for picnicking, swimming, and other recreational activities. The pond was created in the 1700s by damming the Shumatuscacant River to power a sawmill. Designed by the Olmsted Brothers firm, the park was listed in the National Register of Historic Places in 2002. This group of Salvation Army soldiers used the 38-acre pond as a backdrop for their photograph.

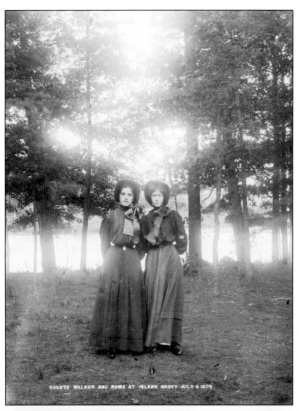

From 1846 to 1865, Island Grove Park was used as a gathering spot for abolitionists. In 1902, Civil War veterans were honored here by the construction of a Memorial Arch and Bridge. Here, two Salvation Army members, Cadets Walker and Rowe, pause for a photograph while on an outing on July 4, 1908.

These Salvation Army soldiers in uniform put their box camera on the ground and let Thomas Drew take their photograph. The Salvation Army was founded in 1865 in London, England, by William and Catherine Booth. The first United States chapter opened around 1880.

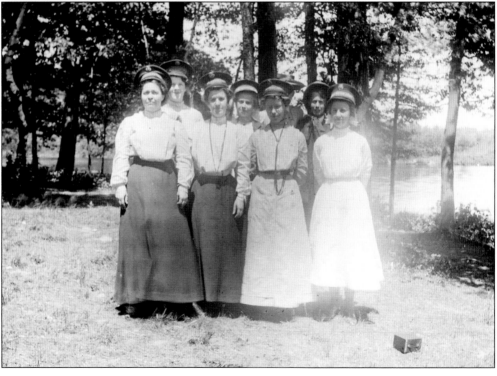

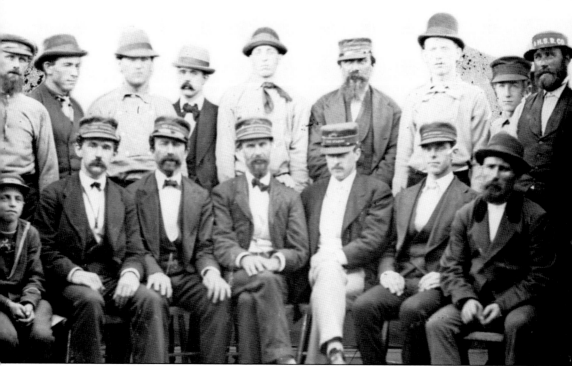

Thomas Drew probably caught these crew members and employees of the Boston & Hingham Steam Boat Company for a photograph at their Nantasket pier. The B&HSB Company was organized in 1832 and operated the *Nantasket*, *Rose Standish*, *Twilight*, and *Wm. Harrison* between Rowes Wharf in Boston and Nantasket. The company went out of business about 1890.

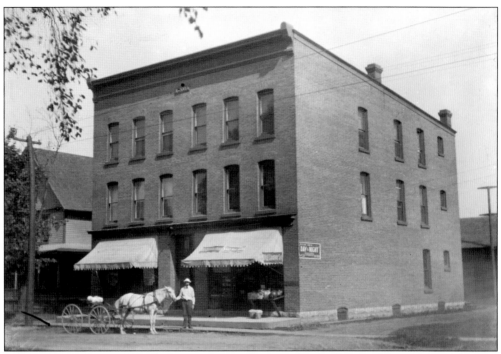

While most of Thomas Drew's photographs are from the South Shore, a few were taken in other areas, such as these two. The exact location of the building shown in these two photographs remains unknown. The large brick building is the Haven Block, and it was built in 1901. The Wm. King Cash Grocery was located in the right storefront. The grocery sign was painted by Patterson, whose address was 17 King Street.

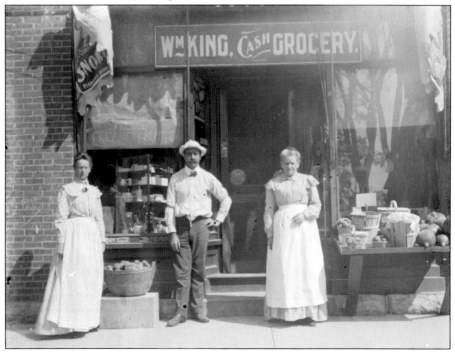

Nine

AND BACK HOME
TO HANOVER

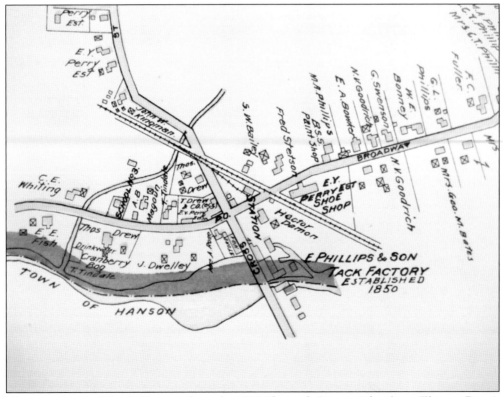

This map detail of South Hanover from the 1903 *Plymouth County Atlas* shows Thomas Drew's neighborhood, home, and store, as well as the railroad station and other places pictured in this book.

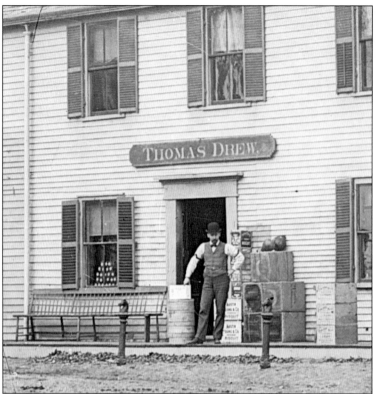

Although Thomas Drew photographed people, places, and events throughout the South Shore, many of his images were taken in his hometown of Hanover, often right in his neighborhood. Some of those images are included in this chapter.

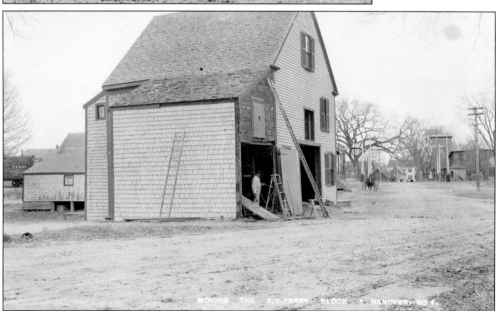

The barn at the west end of the E.Y. Perry block was detached and moved around the corner to Cross Street adjacent to the Tindale cranberry bog, where it remains today as a private residence. Of course, Thomas Drew had to take numerous photographs of the moving process. This view was made into a popular postcard (which is now owned by many collectors), but several other views have never been published.

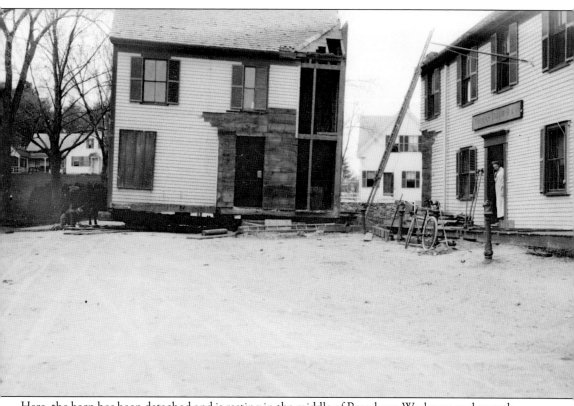

Here, the barn has been detached and is resting in the middle of Broadway. Workmen underneath are fastening heavy chains to the beams supporting the structure.

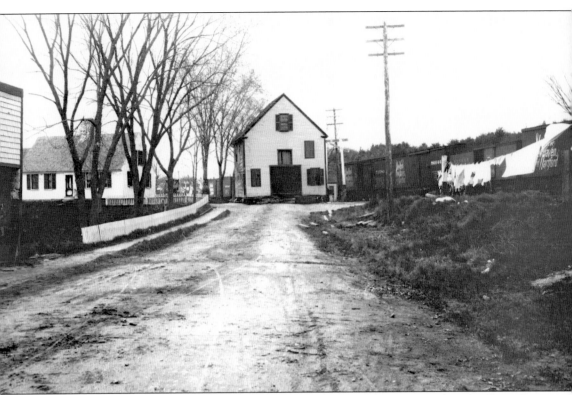

Just to the left of the wash hanging on the line, a horse and wagon stand at the Cross Street crossing. It appears that crates are being unloaded from the New York, New Haven, & Hartford Railroad freight car. Judging from the number of cars, it seems likely that Phillips Bates or other merchants at Hanover Four Corners were expecting a shipment. The barn has been moved around the corner to Cross Street, where it was converted into a house. The house on the left is the Gamaliel Bates house (c. 1771), which was owned by Thomas Drew in 1903. Both of these homes remain, but the center chimney on the Bates house has been removed. The corner of the Thomas Drew Store is just visible to the left.

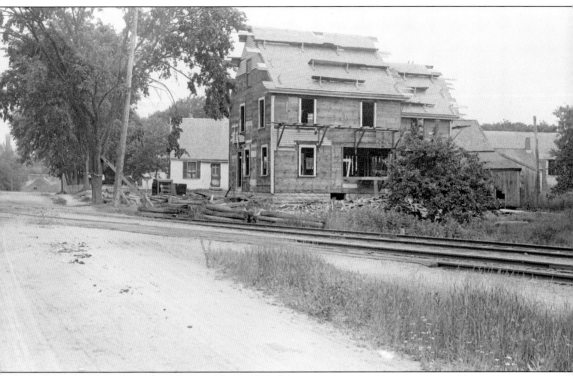

The former Thomas Drew barn has now been placed on a new state-of-the-art ornamental concrete block foundation. The clapboards are almost all removed, and several squares of shingles are on the site. With a new roof installed and windows soon to arrive, the new house is well on its way.

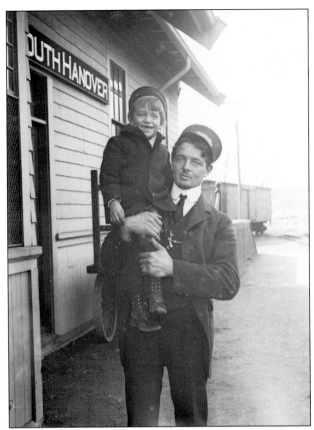

At the South Hanover Station of the Hanover Branch Railroad, a New York, New Haven & Hartford Railroad conductor gives a local boy a boost. This station, located just around the corner from the Thomas Drew Store, was one of three large stations in Hanover.

Thomas Drew instructed everyone to look up and be still, but some boys will be boys. The railroad tracks in the background show that this is the Cross Street cranberry bog behind the Thomas Drew Store and next to the future site of the yet-to-be-moved house.

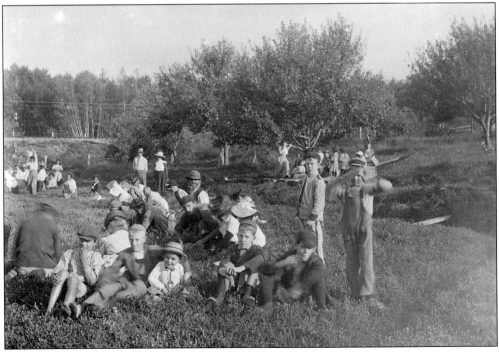

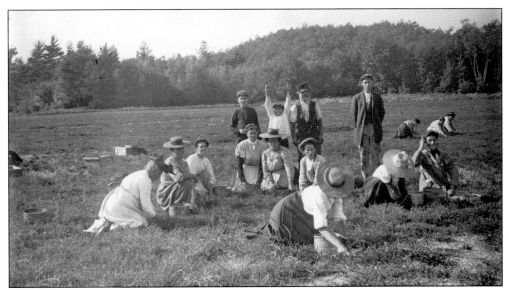

Ella Drew (left, with the big hat) joins the neighborhood folk—young and old—in harvesting the cranberry crop on Ed Tindale's bog. Tindale owned three Hanover bogs: one on land next to Drew's house, another behind Drew's store, and a third further down Broadway toward the Four Corners.

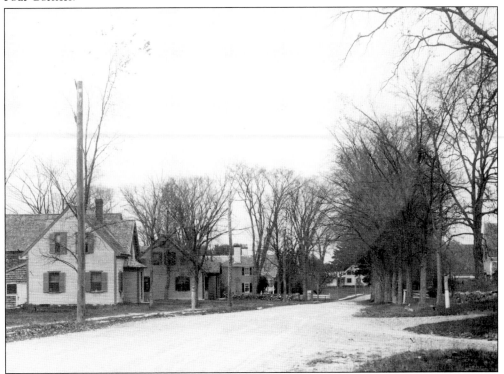

This is Thomas Drew's neighborhood looking east on Broadway with the end of Water Street at the right. Reuben Tower, a clockmaker, lived in the first house on the left. The following houses are, respectively, the Hollis house, Phillips house, Charles Bonney house (only the bay window is visible), and Belcher Sylvester house.

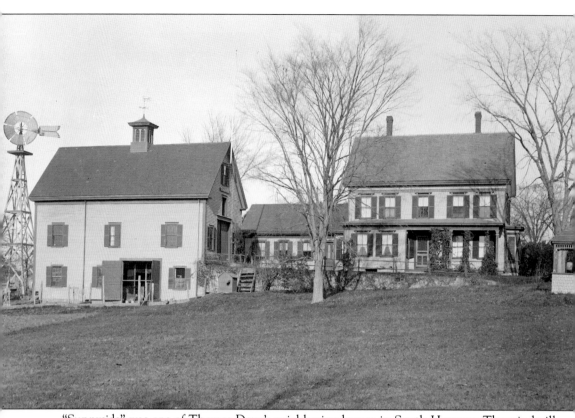

"Sunnyside" was one of Thomas Drew's neighboring homes in South Hanover. The windmill has been gone for many years, but this is one of the many beautiful old homes that still remain on Broadway. The barn burned down a few years ago but has been rebuilt.

This Thomas Drew postcard contains the written message, "this boat is drawn up on Auntie Maria Phillips land." Calvin and Maria Phillips lived at 1010 Broadway and owned the land now occupied by Trailside Lane and Meadow Drive and back to the river. This view shows the remains of a dam just above the mouth of Rocky Run where Jesse Reed built a gristmill and tack factory where he operated 12 tack machines of his own patented design. He later sold his dam, factory, and patents to Elihu Hobart of Abington. While in Hanover, Reed was granted patents in 1814 and 1815 for nail-cutting and nail-heading in one operation, manufacturing nails, and making tacks. After selling his original site, Reed built a shop a little further down the river. He brought water from Rocky Run Brook (which empties from Trout Pond) into a 20-foot overshot water wheel, but during the summer, the water smelled so bad that he could not continue there, and he moved to Marshfield.

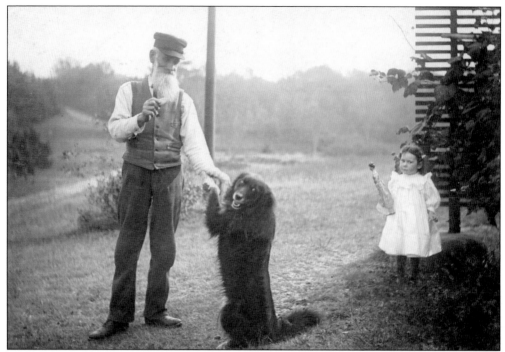

Hira "Bill" Bates (1830–1901), mentioned in an earlier chapter as a hunter who shot waterfowl on Oldham Pond, lived a few houses down from Thomas Drew at 1082 Broadway in a Cape Cod–style home that he constructed. Here, Bates poses with his ever-present dog Simon, who was well-behaved enough to take his gaze off the proffered food to look at the camera!

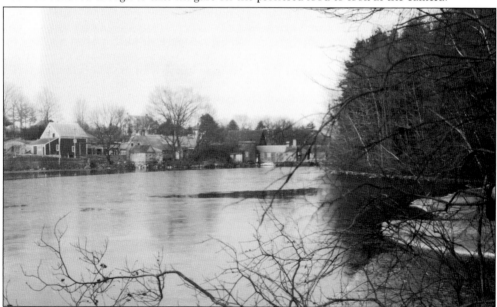

Taken from the Hanson side of the Indian Head River, this view shows the pond at Project Dale with the Waterman Tack Factory in the center and the dam at the right. Across Water Street, to the left, is a barn and 1700s home probably built by Nathaniel Josselyn, the original owner of the dam at this site. The homes in this image, and most of the tack factory buildings, still remain.

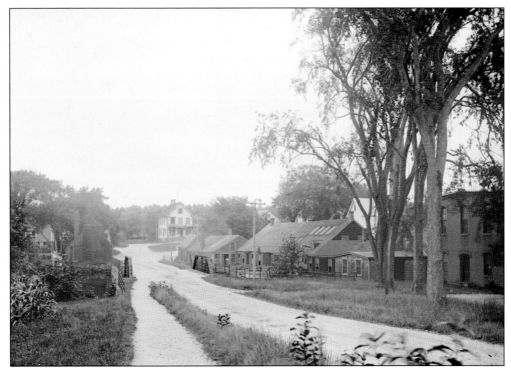

This view looks from State Street in Hanson across the Indian Head River bridge to Cross Street in Hanover. The E. Phillips and Sons Tack Factory, which straddles the river, occupies a site that was used as a forge as early as 1725.

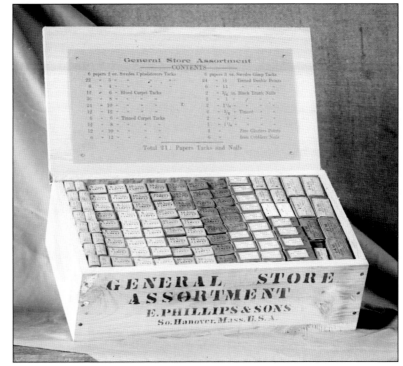

No doubt, the Thomas Drew Store carried this assortment of E. Phillips & Sons tacks. The box contained nine different types of fasteners, including carpet tacks, zinc glaziers points, and iron cobblers' nails.

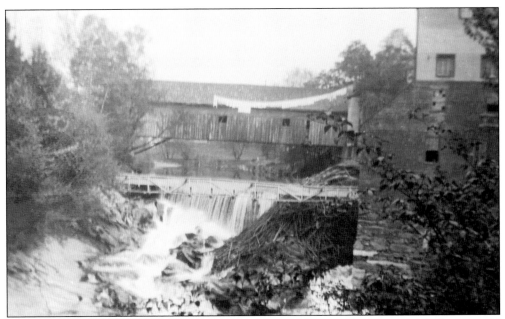

The Clapp Rubber Mill on the Indian Head River was in business beginning in 1873 in the old anchor works in Hanover. It originally used waterpower, but steam engines were employed in 1879. In 1886, a new factory was built on the Pembroke side of the river, and the two were connected by a bridge so the 75 to 100 employees could pass between the factory buildings. This appears to be a very early photograph of that area.

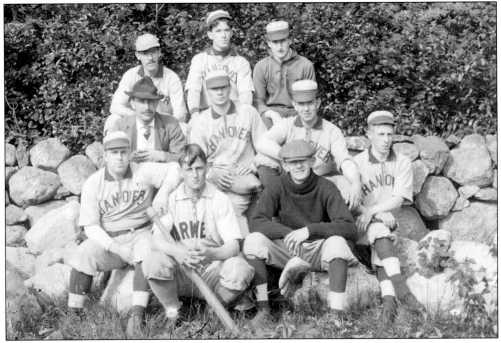

These athletes and coaches from Hanover and Norwell are ready for a baseball game to begin. Check out the bat and glove in the front row—these were state of the art 100 years ago—and the catcher's mitt in the second row.

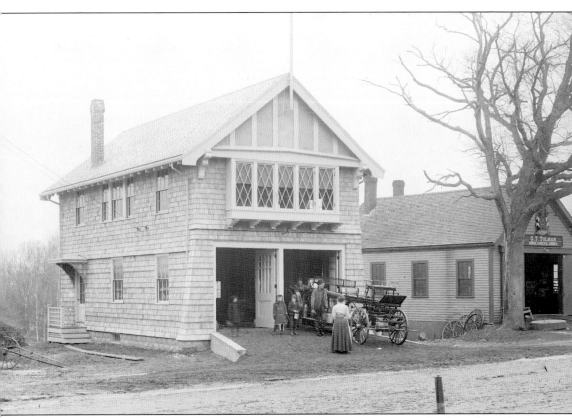

The 1908 *Hanover Town Report* notes that in the Four Corners, "an association has been formed, a new fire station built without expenses to the town, and, through the liberality of practically one family, a first class piece of apparatus has been placed therein." Here, neighborhood folks are admiring the new equipment.

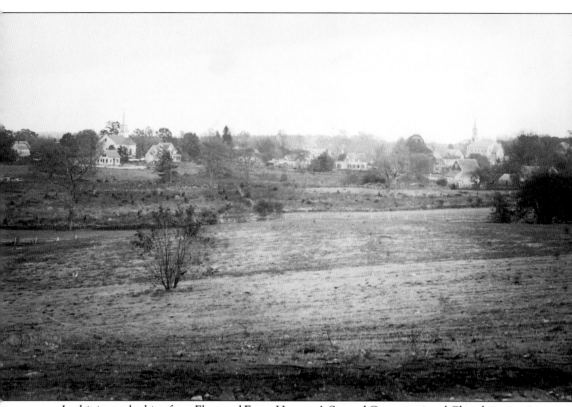

In this image looking from Elmwood Farm, Hanover's Second Congregational Church is prominent on the left. The Four Corners section of Hanover is at right, with St. Andrew's Episcopal Church rising above the horizon.

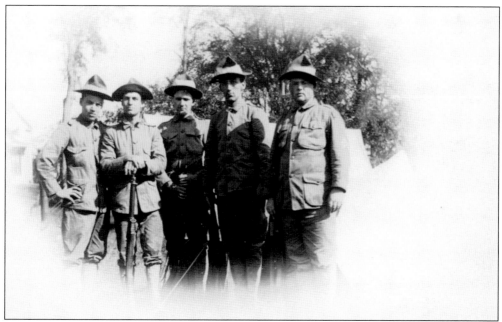

Thomas Drew titled this photograph "5 Worcester Cadets." In 1909, the "Red and Blue War," a military training exercise, was held in southeastern Massachusetts. Mock battles staged between regular US Army troops and Massachusetts National Guard (Mass Guard) members started in New Bedford and ended in Hanover. The soldiers pictured are Mass Guard members.

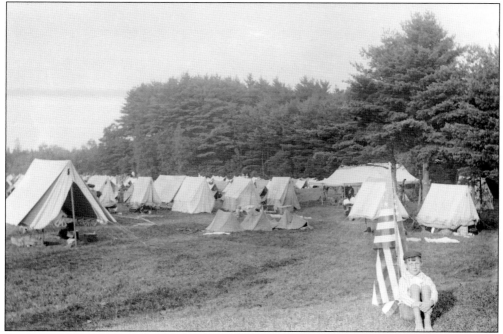

During the "Red and Blue War," troops camped on Sylvester Field on Washington Street in Hanover Four Corners. While the skirmishes did not use live ammunition, the blasts of cannon fire broke windows in the neighborhood. Thomas Drew found a quiet time to photograph the encampment and a patriotic boy.

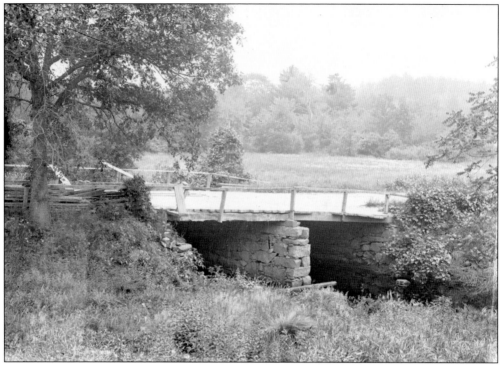

Teague's Bridge spans the Drinkwater River, which separates Hanover and Hanson at the end of Broadway in Hanover. The road to the left is Broadway, while Winter Street Hanson is to the right. This bridge was replaced by a concrete arch bridge in 1907.

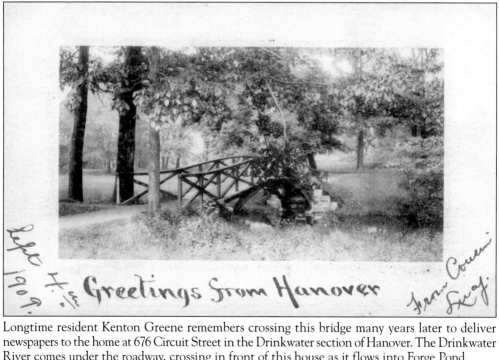

Longtime resident Kenton Greene remembers crossing this bridge many years later to deliver newspapers to the home at 676 Circuit Street in the Drinkwater section of Hanover. The Drinkwater River comes under the roadway, crossing in front of this house as it flows into Forge Pond.

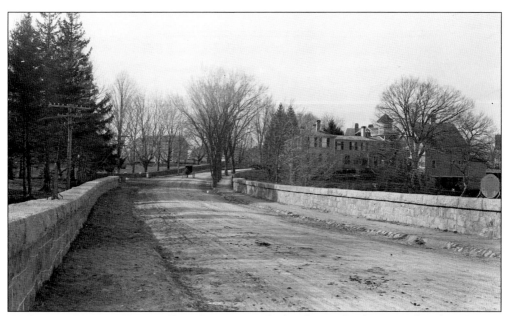

Washington Street in Hanover Four Corners was the local route for those traveling from Boston to Plymouth in early colonial days. The bronze tablets on the bridge parapet indicate that the first bridge was constructed over the North River at this location in 1656 and that the bridge pictured, which remains today, was built in 1904.

The Washington Street bridge spans the North River and connects Hanover (on the left) with Pembroke. As early as the 1660s, this area was the site of the Barstow Shipyard on the Hanover side, with many other yards to follow, including the Turner Yard on the Pembroke side. Shipbuilding was but a distant memory by the time Thomas Drew took this c. 1910 photograph of boathouses.

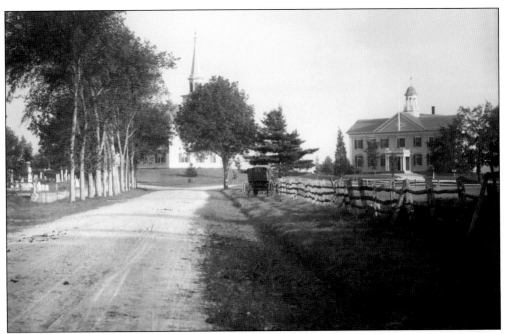

Drew parked his buggy on Center Street to take this photograph of Hanover Center Cemetery (on the left), First Congregational Church (center), and Hanover Town Hall (right). That is an impressive split rail fence around Brigg's field at right.

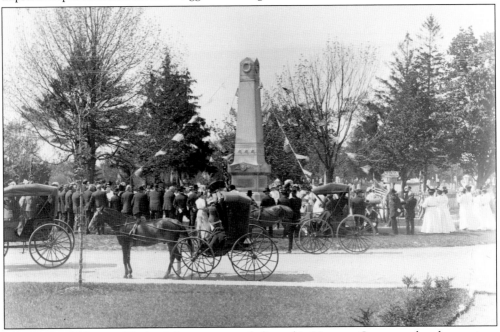

In 1878, the Soldiers and Sailors Monument was dedicated in Hanover Center, and each year since then, townspeople have gathered to honor those who served in the defense of the country and especially those who have made the supreme sacrifice. This photograph is probably from around 1910. There have been many wars since 1878, and a Veterans Memorial honoring all branches of military service has been erected a few hundred feet from this monument.

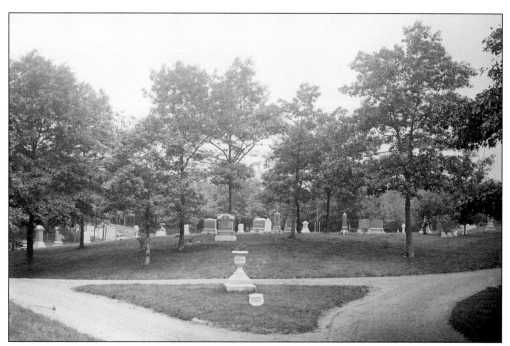

The Memorial Triangle and Monument to the Unknown Dead is located in Hanover Center Cemetery. Wesley and Addie Everson, whose stone is in the foreground, were both alive when this photograph was taken. Wesley died in 1929, and Addie followed in 1940.

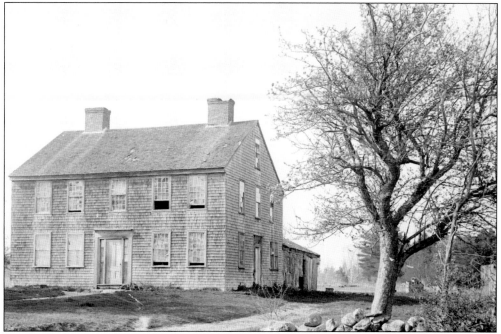

The Rev. Samuel Baldwin house, built in 1759, was located on Hanover Street near the end of Spring Street. It was Hanover's first parsonage, but at the time that it burned to the ground in 1909, it was being used as an apartment house and was known as the "Beehive" because of all the people coming and going.

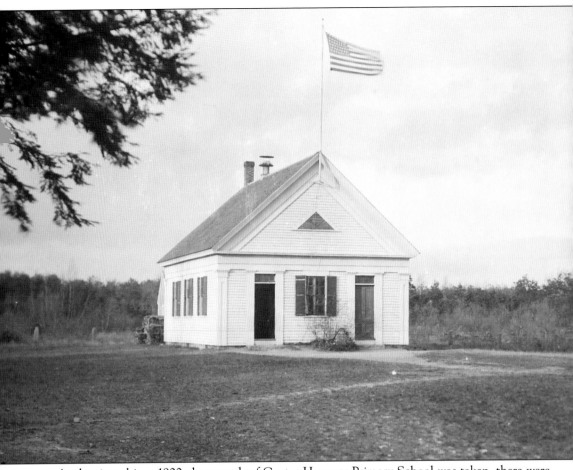

At the time this c. 1900 photograph of Center Hanover Primary School was taken, there were seven district schools. In addition to this one, there was Salmond School, South Hanover, King Street, Whiting Street, Curtis School, and Rocky Swamp School at Assinippi. Center was built sometime after 1850.

This image has been included so that readers can see the staging that Thomas Drew set up to take portrait photographs. A large piece of burlap cloth has been hung from the frame of his windmill and supported by the edge of his shed. Images taken in this manner would have to be planned carefully in order for Drew to get proper lighting on his subject.

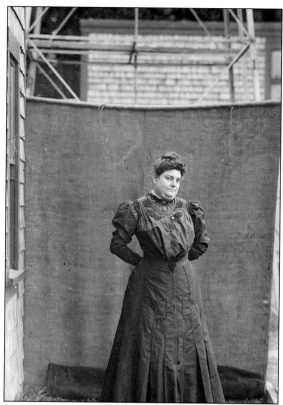

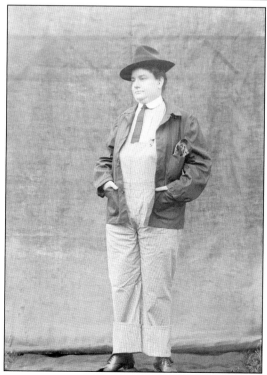

This is another great image. The tie and floral pocket handkerchief perfectly complement the striped overalls, but the pant legs might be a bit on the long side!

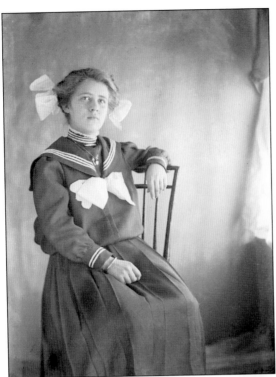

Thomas Drew also utilized his burlap cloth for interior portraits. Here, the girl is sitting by a window that provides bright light from the side.

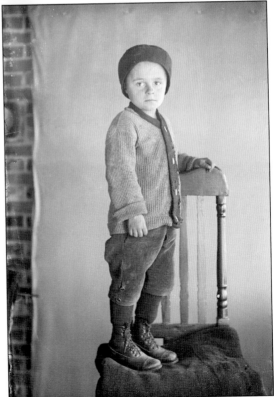

Here, the chimney and wood stove provide clues as to where this photograph was taken. High-top shoes and buttoned knickers were the popular style in the early 1900s.

Elizabeth (right) and Evalina Phillips were two of Thomas Drew's grandchildren. Elizabeth was born in 1897 and Evalina in 1900. "Grandpa" took a number of pictures of his grandkids.

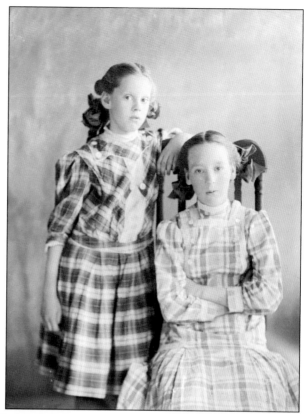

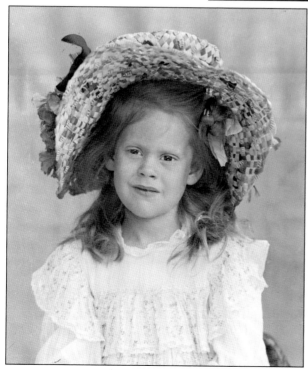

This image of Thomas Drew's granddaughter Evalina is the author's favorite of the hundreds of glass plate negatives that he studied and selected for this publication.

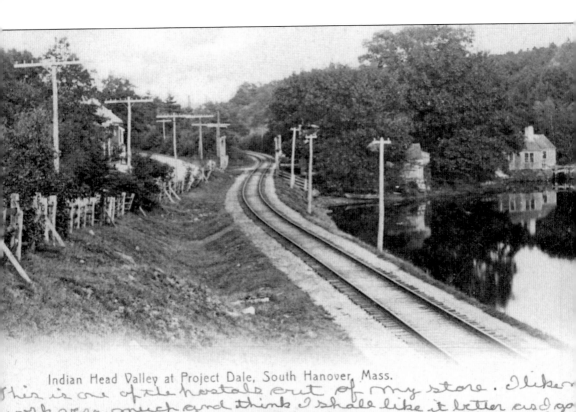

Indian Head Valley at Project Dale, South Hanover, Mass.

This is one of the postals out of my store. I like my work very much and think I shall like it better as I go. Wish you could pop in and see me some evening. I have to keep the store open till eight.

Thomas Drew wrote, "This is one of the postals out of my store. I like my work very much and think I shall like it better as I go on. Wish you could pop in and see me some evening. I have to keep the store open till eight."

The author hopes that the reader has enjoyed dropping in to Thomas Drew's South Shore. His timeless photography is no longer confined to dusty drawers and can now be enjoyed forever!

Thomas Drew's South Shore ends here at the Stetson House Museum, located at 514 Hanover Street in Hanover Center, where the Thomas Drew Collection is archived. The Stetson House was built beginning in 1694 and is the home of the Hanover Historical Society. The museum is open Saturdays from 12:00 to 4:00 p.m. and by appointment by calling (781) 826-9575.

DISCOVER THOUSANDS OF LOCAL HISTORY BOOKS FEATURING MILLIONS OF VINTAGE IMAGES

Arcadia Publishing, the leading local history publisher in the United States, is committed to making history accessible and meaningful through publishing books that celebrate and preserve the heritage of America's people and places.

Find more books like this at
www.arcadiapublishing.com

Search for your hometown history, your old stomping grounds, and even your favorite sports team.

Consistent with our mission to preserve history on a local level, this book was printed in South Carolina on American-made paper and manufactured entirely in the United States. Products carrying the accredited Forest Stewardship Council (FSC) label are printed on 100 percent FSC-certified paper.

MADE IN THE USA